MW01258869

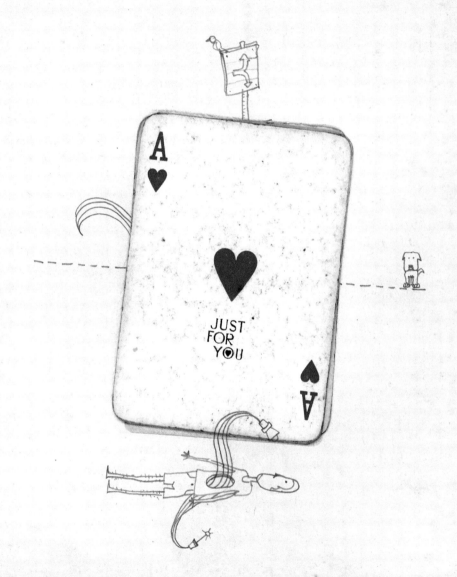

JUST
FOR
YOU

PABLO CORREA

EXP. E. ...
Knafzljva 30
1000 Ljubljana
SLOVENIA

NOSTNO

SYLVIA EST
INDEX

RTE: Rocío Macías Ramos
Rossend Arús, 44 5°.
Barcelona

Barcelona, 7 de enero de 2008

Hola,

tal como quedamos ...
correo ordinario las imág...
de "Justforyou". He ...
ficha ... trabaj...

INDEX BOOK

sacboll 712

ORDEA IZquierda

santisallés

os envío por
la selección
un word con las
o que esta vez
no dudéis en
ya lo tenéis en
otra vez , y hasta

REMITE
Julio B
Aveni
4602

Buenos días Pablo,

Te envío imágenes para el libro JUST FOR YOU, dado que me ha sido imposible envia
vía e-mail y tampoco me ha sido posible a través de ftp gratuitos, así que he optado por
la tercera opción del CD.

Te envío un cd que contiene tres ca... cada una de ellas está identificada con el
número que me enviasteis a tra... del c... o electrónico, que es el 15310

En cada carpeta hay un texto deplico que me motivó a hacer la pieza,
y una imagen, la pieza ... exce... ... corazogadas que contiene cuatro
imágenes que corre... ...de...

Para cualqui... ...uda,

MATTHIAS

ISBN: 978-84-96774-83-4

AUTHOR / GRAPHIC DESIGN: Pablo Correa

TRANSLATION: Silvia Guiu Navarro / Shawn Volesky

PRINTING: Dami Editorial & Printing Services Co. Ltd.

Just for you

DESIGNS FROM THE HEART

www. CORREAPABLO. COM.AR

Contents

contenidos

Introduction 8

Objects 10/87

Cards 88/129

Posters / logos 130/167

Illustrations / photos 168/281

Index of pieces 282/287

Thanks 288/297

DESIGNS FROM THE HEART

Introducción

Introduction

Just for you is a collection of more than 400 pieces of graphic design that were created not for a client, brand or target audience, but for someone special. The pieces shared in this book are very personal. For the designers, the intimate nature of their message makes it a different kind of challenge; the message is the feelings we carry inside.

Through them, the designers, photographers, illustrators and artists from around the world who created them give us a little peek into their private selves. They are pieces that show the sincere side of their creative talent, pieces with a story, the challenge of an act as simple or complicated as saying "I love you".

This book features objects, cards, illustrations, posters, photographs, graffiti and logos. In this sense, it is a graphic book about designs with a story, about the bond between two people, an idea conceived and carried out "Just for you".

OBJETOS

Who would have thought? Twenty-seven years later and despite relentless upheavals in the family and the best home decorating magazines, my mother's portrait is still hanging in the same place by her desk. I was only five years old! Luck was not on my side, and I have never been good at colors or drawing, not to mention design. Nevertheless, there it is. I suppose demonstrations of love are stronger than design. Still, their combination is unique; both are personal and non-transferable. In this respect, designers are doubly lucky: first, they need to devote themselves and, second, they know how to do it. Congratulations!

Jaime Gasset Rosa

Objects

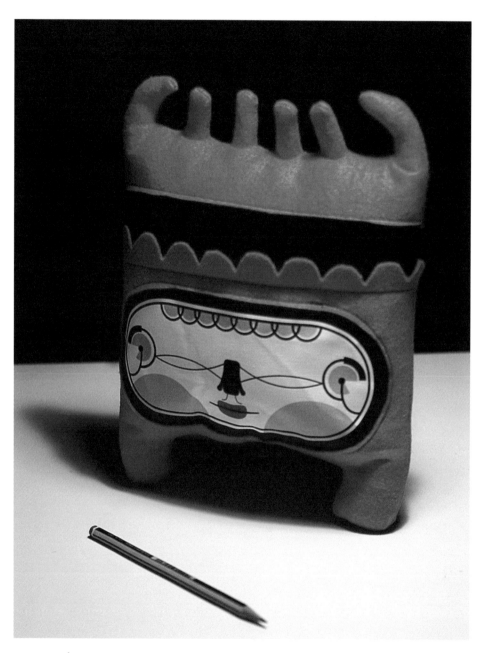

● | MAR HERNÁNDEZ - MALOTA

Orange bug
I wanted to make a special gift, something
unique and very personal.

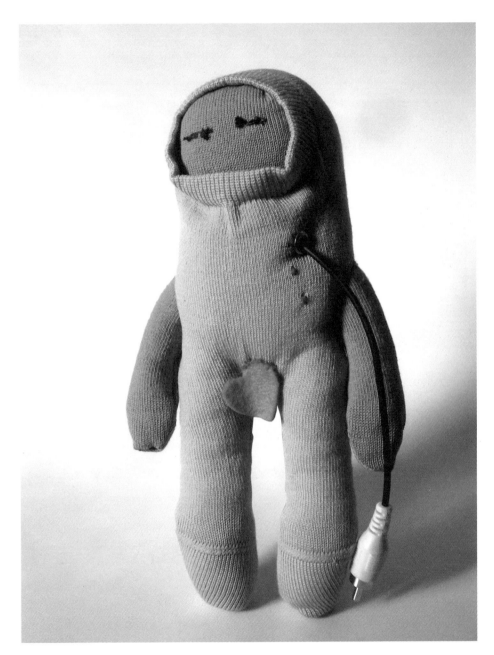

ROSER LÓPEZ MONSÒ / XAVIER JUANHUIX FUENTES

Glups!
The challenge was to create a rag doll with a pair of recycled socks. The desire to create something appealing meant demanding true love, making people fall in love, and falling crazily in love.

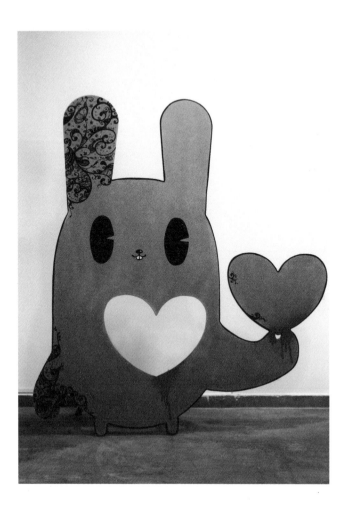

El buen dolor
This is a giant wooden rabbit made for a boy with a broken heart, who was still happy he had loved someone at all.

JIEM

This is a little wood painting for my new love. It's an amazing story. I left my last girlfriend -we were together for seven years!- for "Flo" in December. So, I had a lot of things to show about my old relationship but not much from this new one!

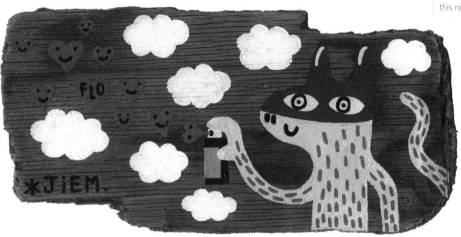

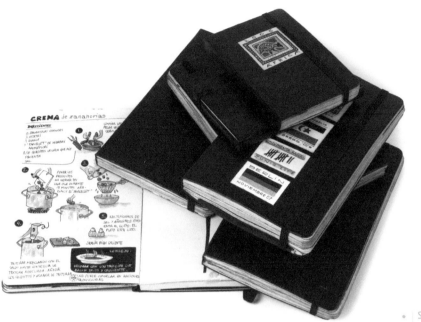

• | SANTI SALLÉS ARGILA

A set of notebooks with illustrations, sketches and ideas that I have been working on for the last several years. They are part of me and my memories. Some of them are from places I have traveled to.

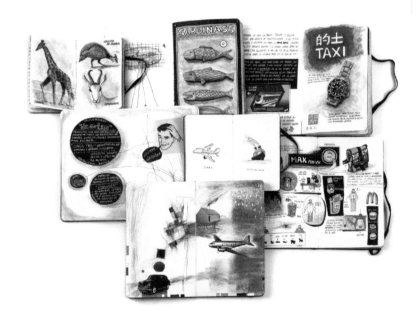

CRISTO SCHMAL

Mini pop-up fanzine
A private gift.

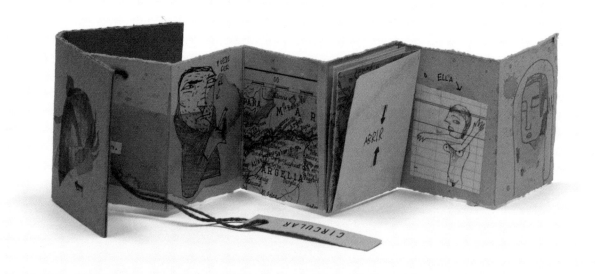

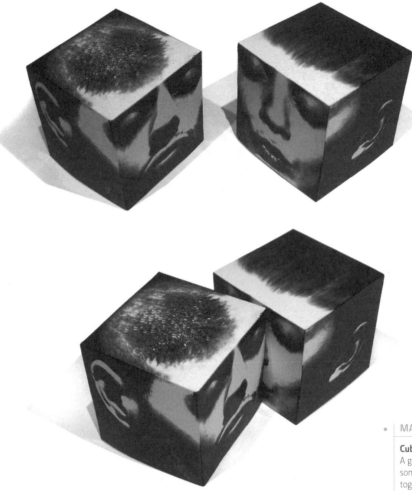

MARIO RODRIGUEZ

Cubes
A gift for my girlfriend. She wanted something that we could assemble together. These are both our faces. We can kiss with our whole face. The idea of fitting together perfectly of being one of each other, was funny.

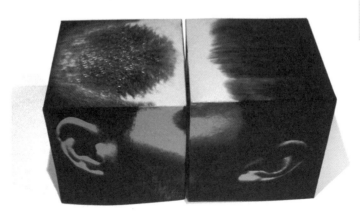

SARA PEDRERO DÍAZ

Sushi that's never past its sell-by date
My friend Pablo is crazy about sushi.
He always wants to go out to Japanese
restaurants, so for his birthday, I made
him this assorted tray of sushi with no
sell-by date!

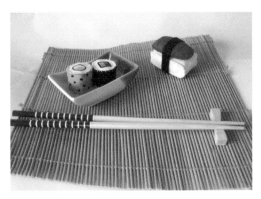

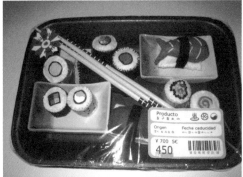

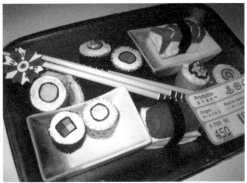

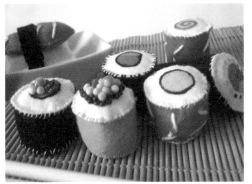

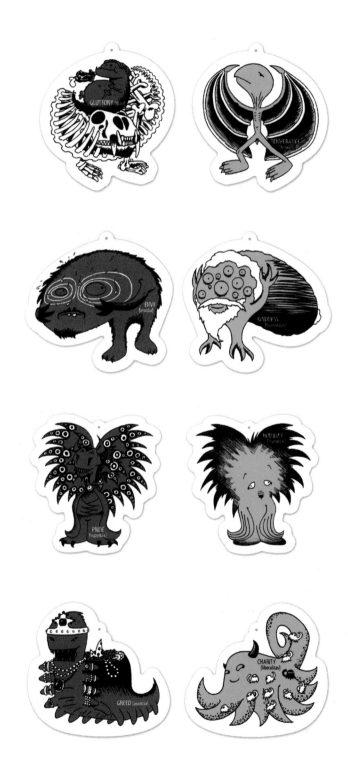

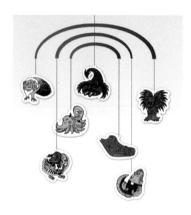

- DR. MANTA

The 7 Deadly Sins vs. the 7 Holy Virtues
Last summer, two good friends of mine got married. Before the event, we discussed the whole idea behind the act of marriage and how it has changed over the centuries. What in the beginning was a sacred act taking place in the church before God is now more of a legal or social act between two people in love.

I designed this mobile for them as a wedding present to give their wedding a little taste of old-school Christian guidance. Now they have a guided map of what to avoid in the future, and by that, I mean both the sins AND most of the virtues. However, I did stress the point of making an exception during their wedding night, so that they could totally engulf themselves in one of the seven sins.

I think you know which one I mean...

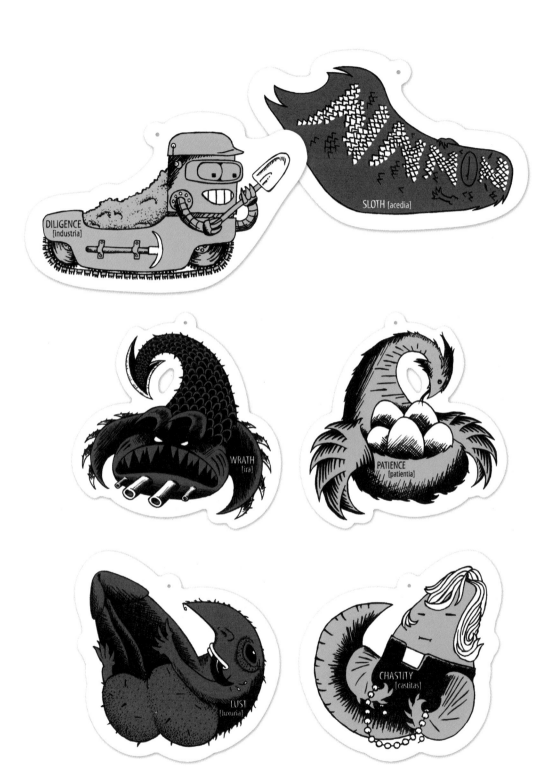

NOÉ MENDOZA CUEVAS

Searching for the perfection of a red star

I made this book as a gift to my professional colleagues, the kind that have always been there and for some reason or another have always supported me and encouraged me to keep up with my work. They are the people who are always around but whom you never seem to spend enough time on.

"Searching for the perfection of a red star" is not about perfection. It is there to encourage those who are giving all they've got to finding their own star. It might be red, yellow or any other color; the important thing is that it's a star.

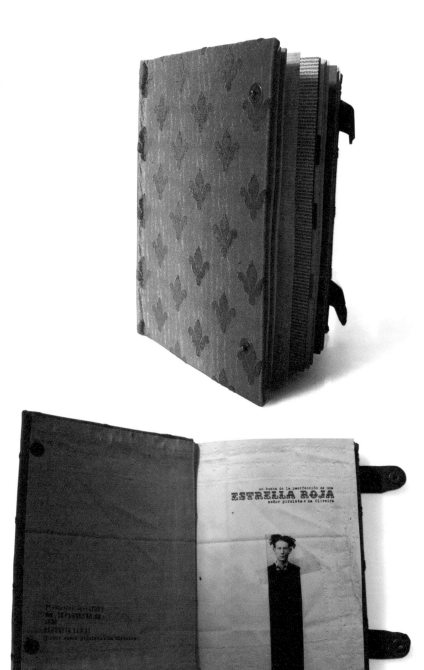

YANINA ARABENA

Guille's notebook

"You just have to eyeball it." Or at least that was the inside joke among friends in a morphology class that led to a set of sketches, which, in theory, were supposed fill what looked like a handmade notepad. Another day not long after — or maybe it was indeed some time later — that bundle of papers, which were just asking to consummate an internal desire latent in a left ventricle, appeared on a lap, all smiles. With tear-stained eyes, the ventricle observed it together with other eyes that were calculating a potential action, an "interaction" that longed to take up residence on a page in that sheaf of papers. And why not? The left ventricle wasn't looking for a companion, but it was conscious of a certain irksome and growing void. An eternity later, that emptiness took flight, making it free to pump and pump the will to dance into certain hands. As chance would have it, those hands loved dancing on paper. And they have never stopped.

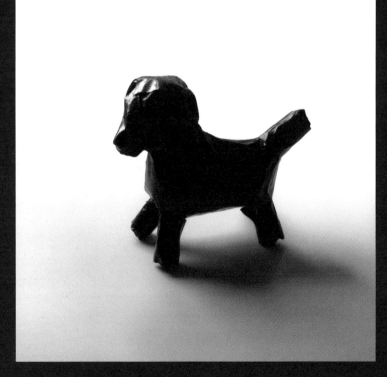

- **JUSTIN HJGHER**

Toto

Toto is a dog made of all the notes, letters, drawings, musical compositions, etc. given to us by specific lovers from our past. We took everything, wrapped in up with masking tape and shaped it into a dog. He is the guard dog of all our past secrets, and we give him to our past lovers when we're ready to let go.

- KARIANN BURLESON

Marginalia
This piece was inspired by the
spirit and sensitivity of my friend
Eric. For a moment, I wanted to
hold his imagination captive and
get him to wander down this little
poetic (ephemeral) path of reverie.
I gathered these odd bits of
nostalgia in a mind and meandering
heart, romancing the random and
revealing the everyday...

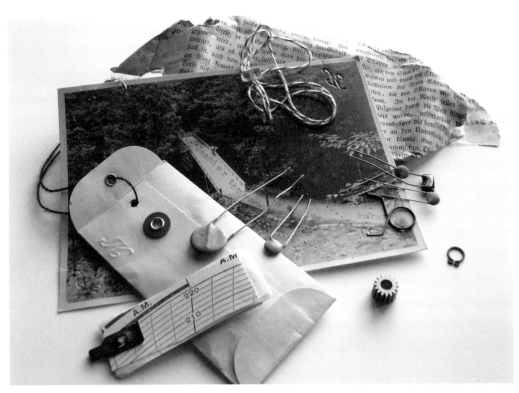

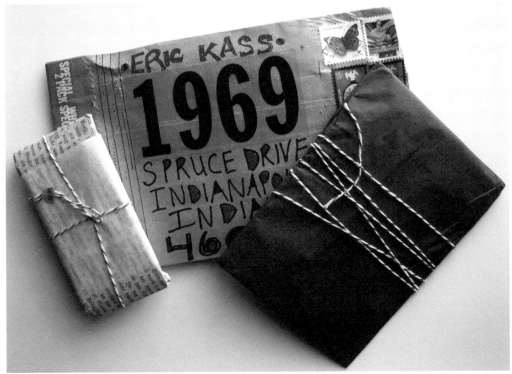

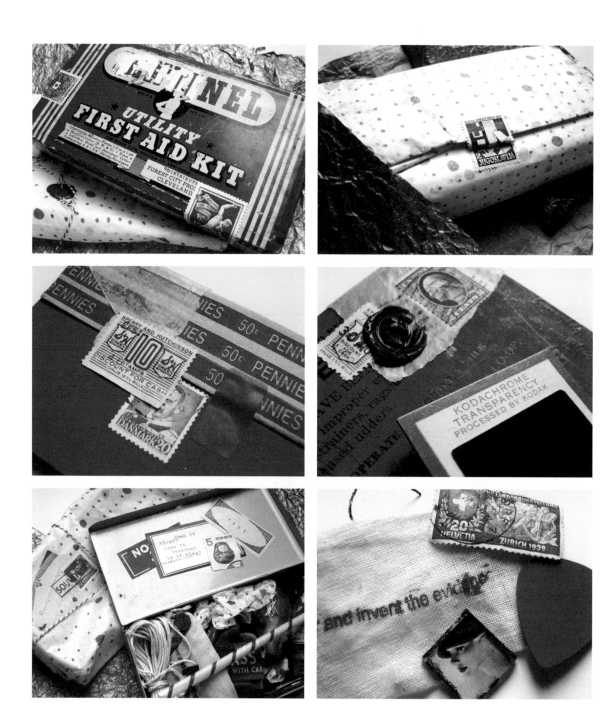

KARIANN BURLESON

What is this blood?
Urgent, red, true, essential (fierce),
life, love, self, connection, and the
veins of mystery it flows through,
ultimately transcending it all... My
gift to Eric was made by heart, a
bleeding heart. It is a metaphorical
kit with an assemblage of found,
personal, coincidental and
symbolic tokens, objects, feelings
and ephemera... It was an merging
of his gifts to me: openness,
honor, and hope... A soliloquy and
perhaps celebration of all this.

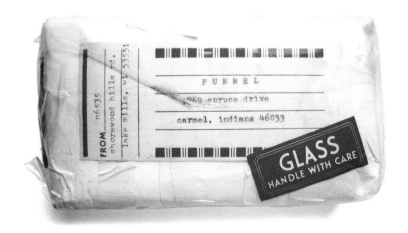

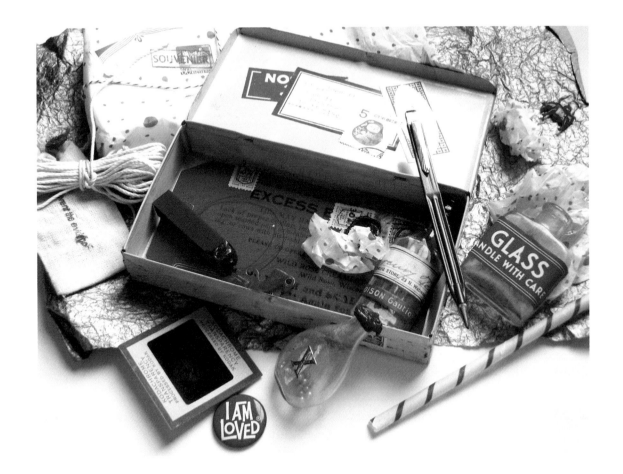

• **HOLA POR QUÉ**

You and me.

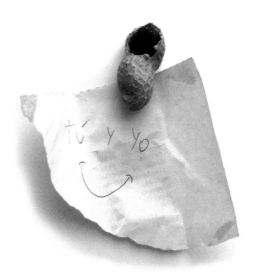

ELIANE MANCERA

Bombita
I made this for my boyfriend's birthday. I was planning to give him a book, but I wanted to do it with more love and dedication. Only then would it be special. So, instead of wrapping it, I made this felt doll with a pouch on its back to put the book in. Later, it can be used as a pillow or a bed buddy.

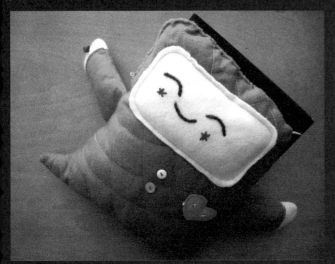

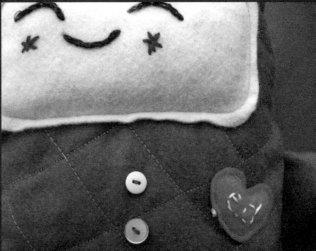

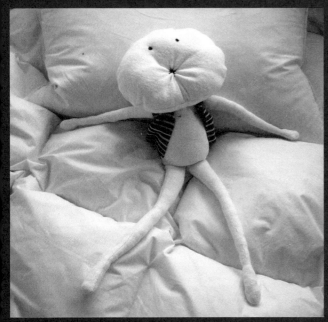

MARIA CARLA GNOATTO

Ass Face
Ass Face was a drawing by a friend. For her birthday, I made it out of fabric and gave it to her. When I gave it shape, it started to come to life. Now, it lives together with three more friends.

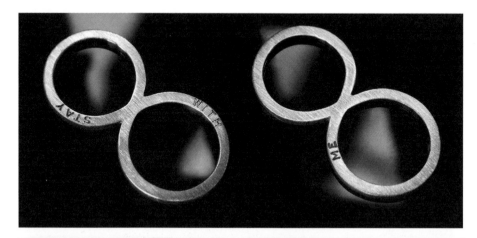

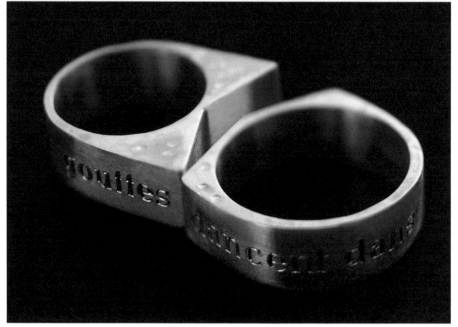

Wind
Pieces inspired by other artistic works made by their future recipients. "Stay with me" was inspired
by a picture, and "Comme deux gouttes jouent dans la mer" was given as wedding rings.

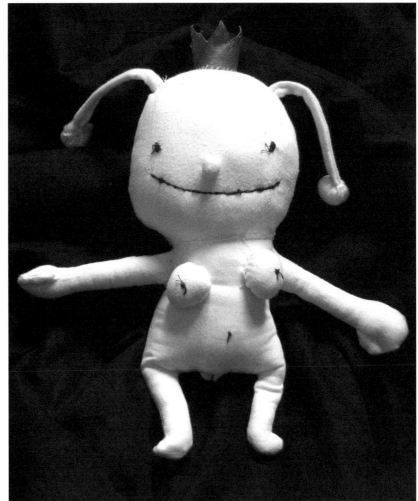

ISABEL KLETT

Little princess

Little Princess is a character who I invented for my boyfriend. (There is also a Little Prince). They are two aliens from two different planets, but they love each other very much. I draw lots of small stories about them. For his birthday, I made him a princess out of cloth.

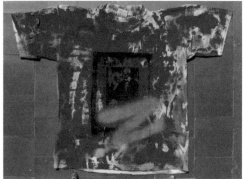

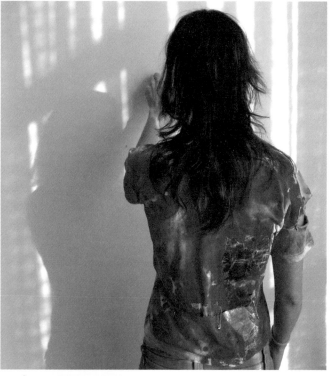

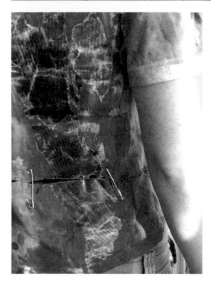

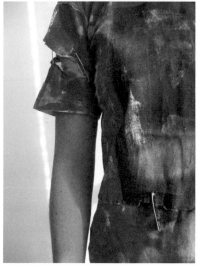

· **EDUARDO GONZÁLEZ VILLAMAÑÁN**
HOLA POR QUÉ

Two touching skeletons

Ana had a rather strange way of dressing, which I totally loved. One day, I saw her wearing a duvet cover as a dress. So, I made her this shirt. I started splattering it with paint, and I covered it with holes, safety pins, and a print I had made of two hugging girls with skulls instead of heads. On the back, I put some pieces of newspaper and painted over them with varnish so they would not fall off. She wore it a lot, and it looked good on her. Even so, the duvet cover was still more elegant.

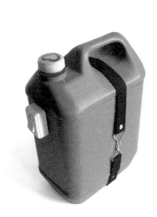 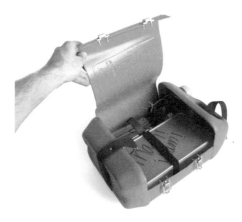

● | ANA ESCALERA MOURA | HOLA POR QUÉ

Green gas can

I found this gas can on the street, and I liked it. Later, I turned it into a briefcase/lunchbox/flashlight and gave it to Vicius when he got a job working at a factory. It was the first time he was working for someone else, and he had to get up really early for work. Vicius is your typical night owl who isn't even a person before noon, so aside from everything else, getting up early was a real nightmare for him. He was a sorry sight. It made me suffer just looking at him, so I decided to make the lunchbox, thinking he could take his lunch to work and feel a little more at home. He really liked it but never got to try it out, because they fired him after a week. He has never had another job that required him to get up early. Much better for all of us.

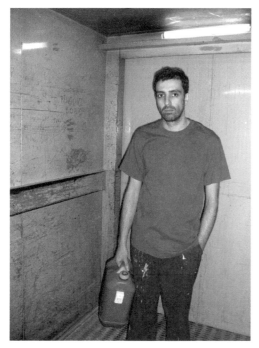

JUHA FIILIN

I made the originals of these drawings in a little, old sauna in the middle of nowhere in Finland. They are based on the few trips I made to some local bars. Using old wooden wine boxes as a medium really supports the stories.

- **Soundtrack**
 The house band keeps on playing the same moody Russian classic balalaika. The bartender has got some dirt in his eye.

- **The Wolf**
 The wolf is up to no good, and the home brew is gasoline for disaster.

- **Poor Little Rabbit**
 If you let the fat face down, you pay with your life.

Love at First Sight
In this dark and humid bar, there are many drunk apes and just one gentleman to offer the lady a drink.

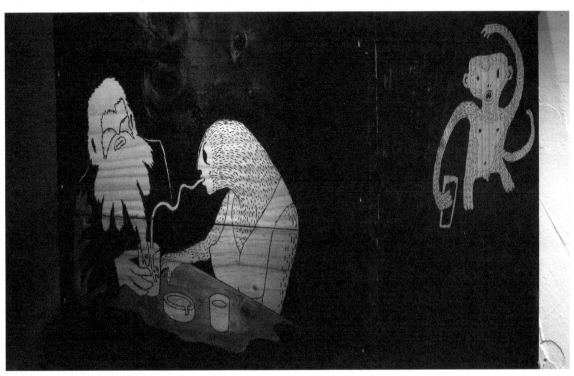

Happy Hour
While hanging out with the big guys, you get to meet the little guys too.

Black Tide
Octopus gets sick in the waves.

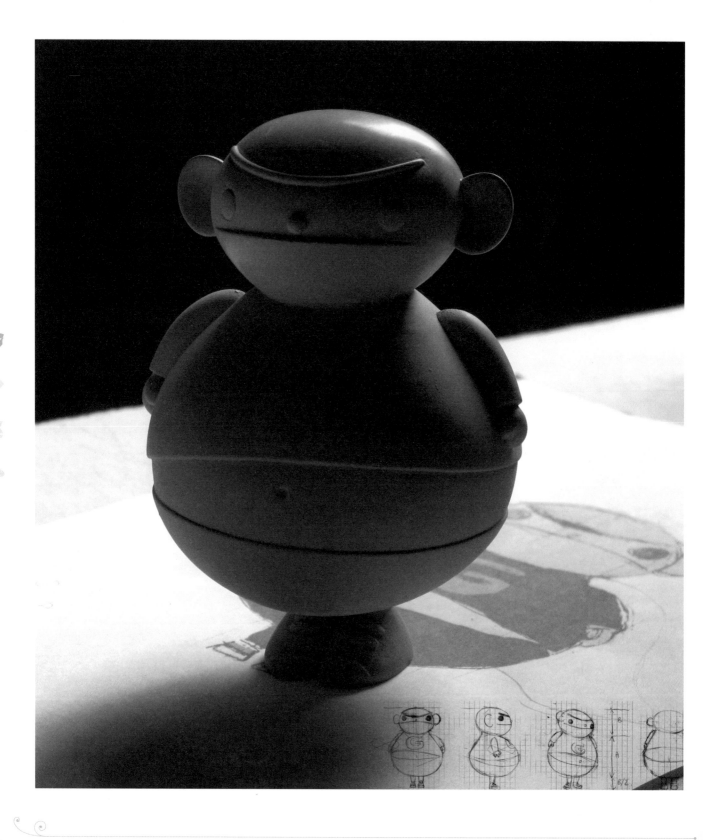

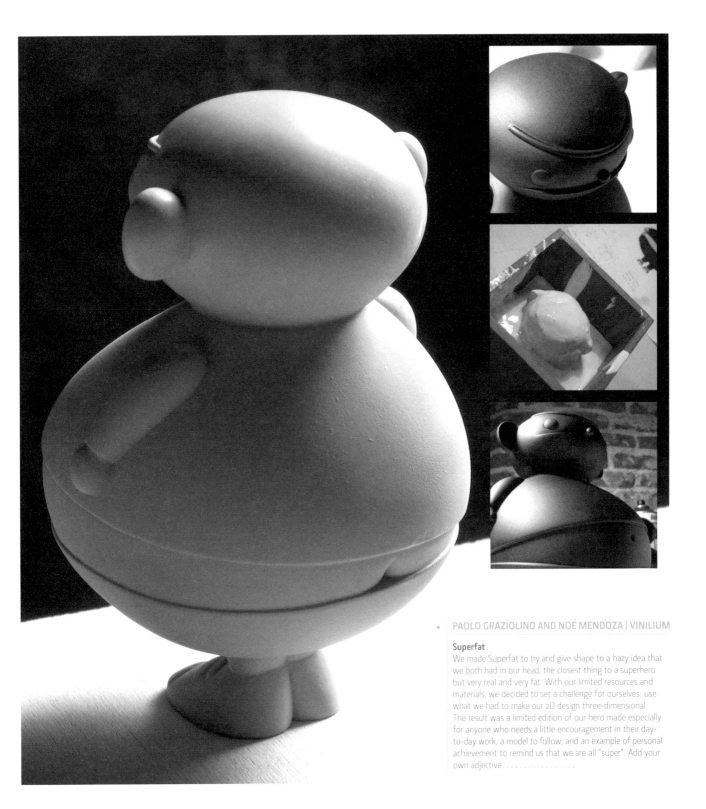

PAOLO GRAZIOLINO AND NOÉ MENDOZA | VINILIUM

Superfat

We made Superfat to try and give shape to a hazy idea that we both had in our head, the closest thing to a superhero but very real and very fat. With our limited resources and materials, we decided to set a challenge for ourselves: use what we had to make our 2D design three-dimensional. The result was a limited edition of our hero made especially for anyone who needs a little encouragement in their day-to-day work, a model to follow, and an example of personal achievement to remind us that we are all "super". Add your own adjective:

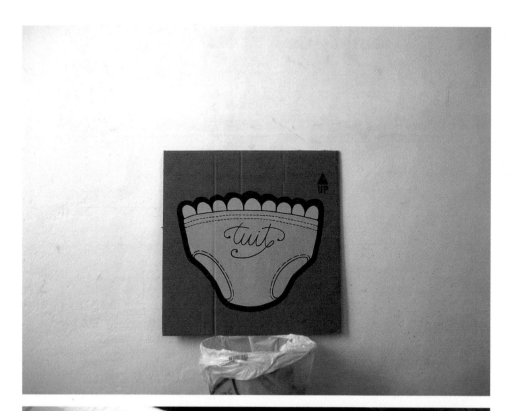

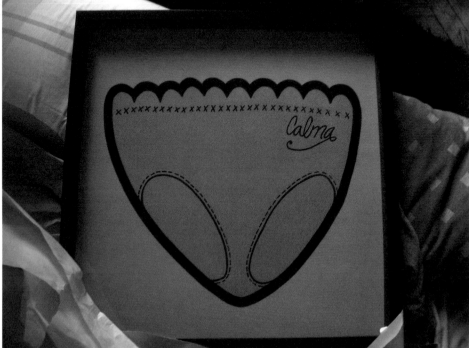

● | MARIO RODRIGUEZ

Tuit calma
These are paintings I made for
my ex-girlfriend. I gave them
to her for Christmas, because
I always liked panties.

ANA CARNICER GUZMÁN

a.duo
T-shirts are said to be a mode of
personal expression, a way to wear
a message. In this project, we decide
to establish the first-ever dialogue
between T-shirts.

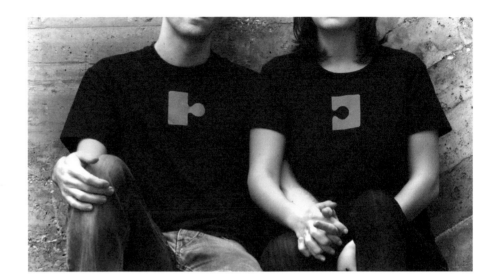

JOHN SAYLES

Anderson Family Reunion Invitation
This invitation was a labor of love! I
created 30 invitations, each one by
hand, including the boxes they arrived
in. The boxes were made of old barn
board, the covers of the invitations
were leather, and each was branded
with the family insignia.

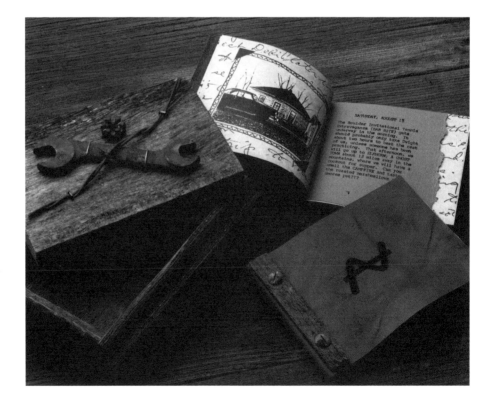

MARIA IGLESIAS PASCAU

Blanket for Otto
My appointment as Otto's unofficial, alternative godmother made me sew this blanket so he would always have us close to him.

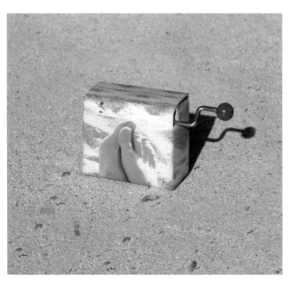

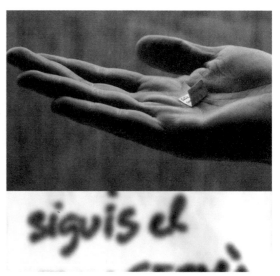

MARTA RIAGUAS OLIVA

Music box
This was a present for my boyfriend. The picture shows our feet together at the beach set to the song "Love is in air".

MARTA RIAGUAS OLIVA

Micro Private Letter
This was a present for my brother to show him how happy I was to have him as a brother.

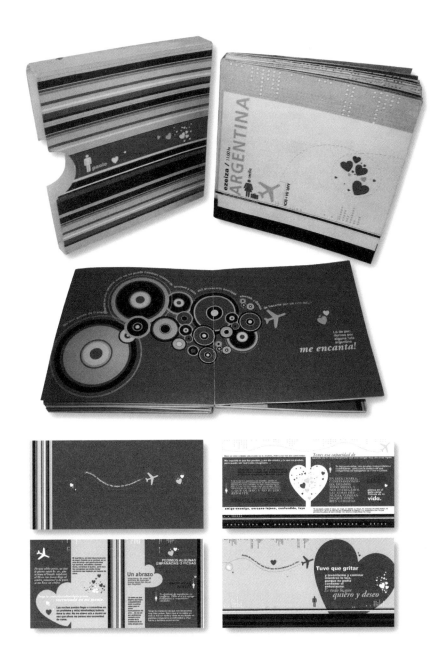

- DANIELA ACHOYAN

Chronicle of a love foretold

She is from Argentina. He is Italian. And theirs is a love that grew between characters and monitors, keys and anxious visits to Outlook, a true tale of love that grew through the most beautiful of e-mails. After a time, their love was strong enough to cast aside the computer, catch a plane and be together once and for all. That is how she came to fly. Her destination? He, in Italy, waiting for her and for everything they had built together. She is my friend, and I thought I should say goodbye with a some sort of gift. That is the story of this object, a small book compiling all of their e-mails that went back and forth, like proof of a love full of emotions. That is what this book is: the chronicle of a love foretold, one that culminates (and begins!) with the face-to-face encounter of two beautiful human beings.

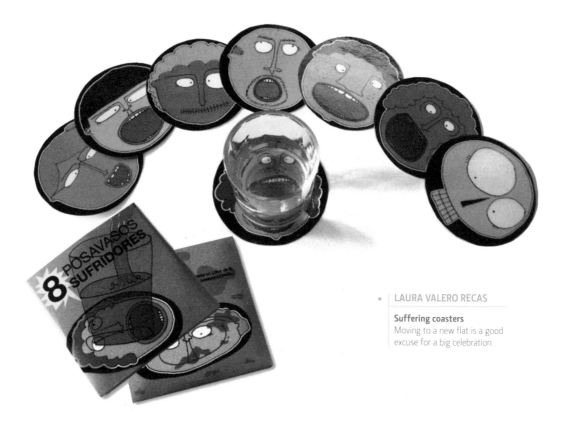

LAURA VALERO RECAS

Suffering coasters
Moving to a new flat is a good
excuse for a big celebration.

JOSÉ SANTAMARINA

Airplane
What can you do with an IKEA box?

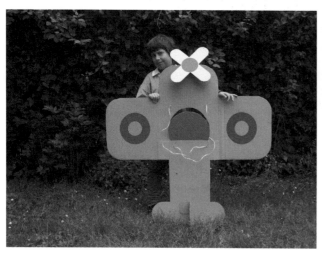
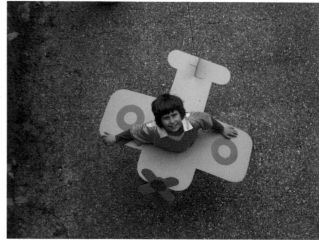

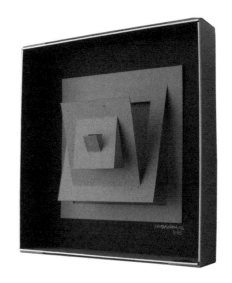

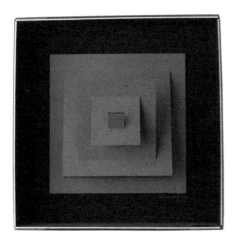

• JOSÉ SANTAMARINA

Christmas Cards
To wish a happy New Year in a special way.

- ## JUAN MARTINEZ LAHIGUERA

MIGRATIONS 2008

A calendar dedicated to all those people from anywhere in the world who are
forced to leave their homes and families in search of better living conditions.

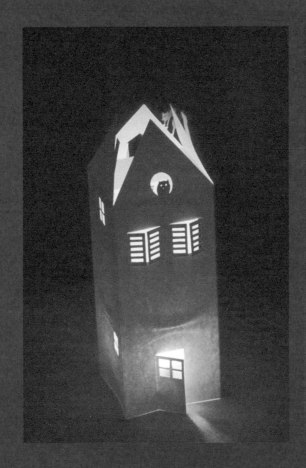
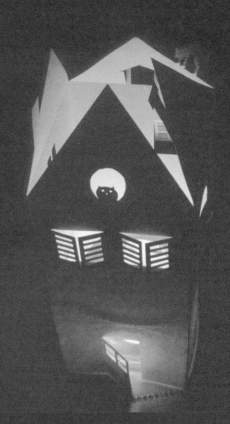

ANNE-LISE DERMENGHEM

Paper house
As a light-up decoration for my children for Christmas, because
Christmas has to be magic. This little house is full of dreams. You can
imagine lots of stories about it.

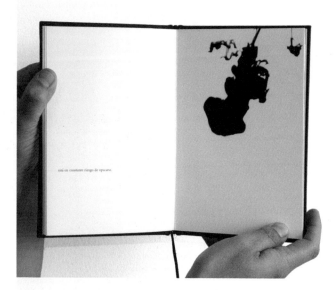
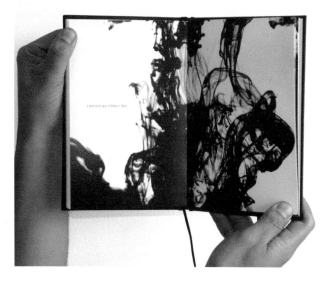
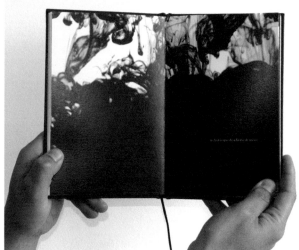

• **DIEGO CONTRERAS JARAMILLO**

B/W

This is a book that I made for my family and friends as a Christmas gift. The book starts out white and gets darker and darker until it is totally black. The images illustrate a personal text about the bright side of life.

- ### ERIC KASS

Bulging Book of Ephemera

For years I've collected mundane, yet evocative, printed materials from the past and present that move me. These little "soul souvenirs" of our lives, made into a little book bulging with life, has become one of my favorite pieces, and I truly love it.

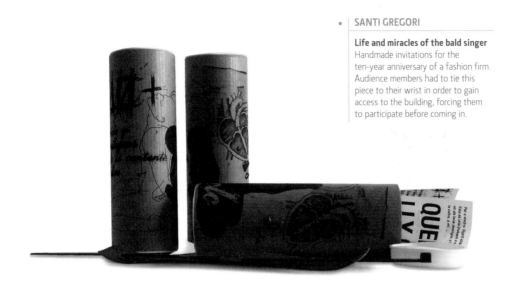

SANTI GREGORI

Life and miracles of the bald singer
Handmade invitations for the
ten-year anniversary of a fashion firm.
Audience members had to tie this
piece to their wrist in order to gain
access to the building, forcing them
to participate before coming in.

● | BJÖRN BÖRRIS PETERS

DATA PILOT Sticker Compilation
DATA PILOT was conceived for
those who recognize that people
understand content far better by
pasting stickers and reading texts
than by reading the straight, linear
passages found in traditional books.

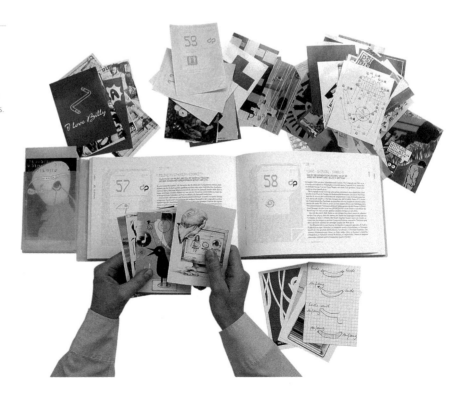

CASEY DENBLEYKER

2006 Holiday Gift
Every year we design and produce a holiday gift for our clients. We are a small design studio and really value a personal relationship with our customers. This is our way of showing them that we appreciate who they are and enjoy working for them.

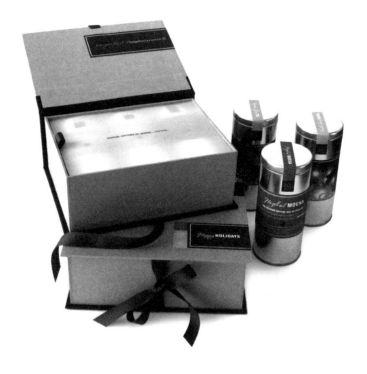

KENN MUNK

Antlor - SecuriTV
Antlor - Security is a DIY paper-based twist on CCTV and hunting trophies. The "wooden" plate is often the only thing that makes these subtle designs stand out from normal surveillance cameras.

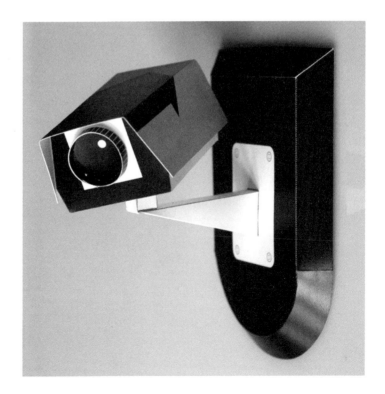

SARA PEDRERO DÍAZ

Night of love
For my parents' anniversary, I wanted to treat them to a romantic dinner for two, but I had to do something to camouflage the impersonal act of giving money.

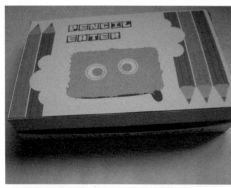

SARA PEDRERO DÍAZ

A pencil case for Javi
I have a graffiti-artist friend whose bag is always full of colored pencils in case he feels the urge to sketch something. I made him a pencil-eater case that stores the pencils in its "stomach".

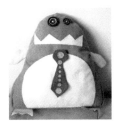
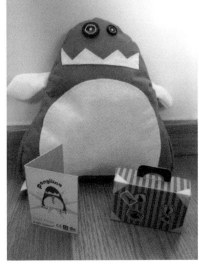

● | SARA PEDRERO DÍAZ

Ponguino
A little drawing that came to life in my mind and became a character that traveled around the world. A cuddly toy that arrived from Antarctica to a friend's house for his birthday.

● | SARA PEDRERO DÍAZ

A handbag for Iso
I made this for my friend Isora's birthday. Her favorite colors are white and black, and she needed a handbag.

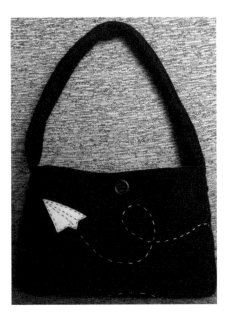

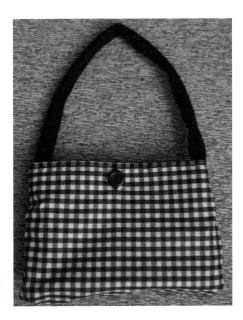

2007 YESDESIGNGROUP Holiday Snowflake

Every year, YESDESIGNGROUP creates a unique holiday gift for its friends and clients—something decorative and sculptural that people would want to keep and cherish. This year's creation combined two hand-drawn snowflakes that were supposed to feel natural and organic. We die-cut pieces out of foam and plated them with uncoated, bright white paper to give the snowflakes a delicate, handmade feel. Our hope was that their sheer presence would put people in the holiday spirit and achieve our personal goal of topping our previous year's creation which was made of paper.

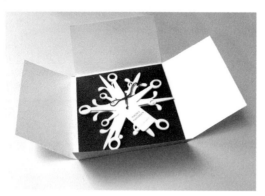
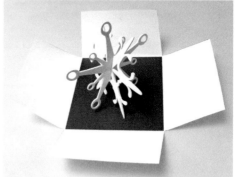

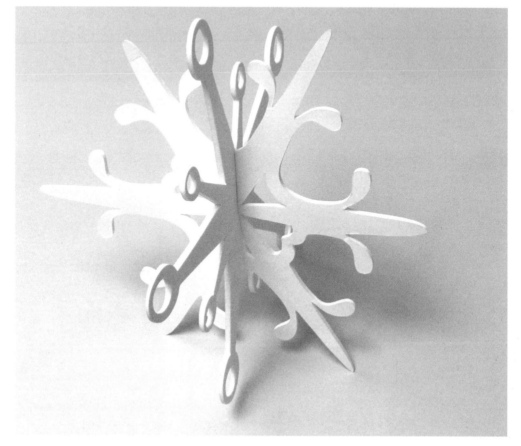

● **DANIELA MANZOTTI**

A Picture of Sonja in 30 Presents
Sonja was turning 30, and we wanted to give her something special and meaningful. So, we chose 30 objects related to her and put them together to make a picture of her colorful personality.

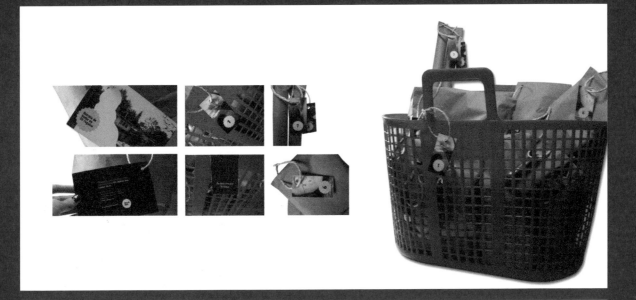

- **EDUARDO ABREGO BLANCO**

eZús

The idea was to make an action figure based on a drawing. I tried making a 3D version out of fabric, foam and clay. Making a single piece is a useful experience, but you would never be able to make a large amount by hand. To make the cloth eZu, I went to a sewing workshop, where some very friendly retired women showed me how to make patterns. That was enough for me to make an eZu and give it to a friend. Things did not turn out so well with her, but she still has the eZu. That's something at least!

- **LAIA CALVET**

Casual stickers

Last Christmas (2006), I made a sticker album with envelopes for the band Casual. The idea was that all of the members of the band had to meet to trade the stickers.

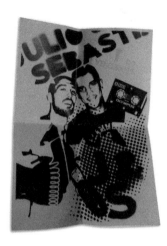
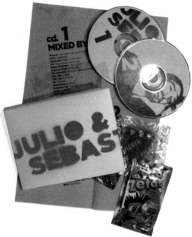

- **BELEN GOMEZ DE LAS HERAS**

Digipack Julio&Sebastian

For their birthday party, Sebas and Julio asked me to design a pack containing two CDs of music that they had each picked out, which they would then give to everyone that came to the party. In addition to the CDs, we put a few more surprises in the pack, including a small poster with a list of all the songs on the CDs.

EDUARDO ABREGO BLANCO

eZús Kalipo
A handcrafted version of the simplest, most functional cuddly toy in the world.
Not only the symbol of my firm, it can also be used as a travel pillow, a headrest
for you sofa or a toy for your cat.

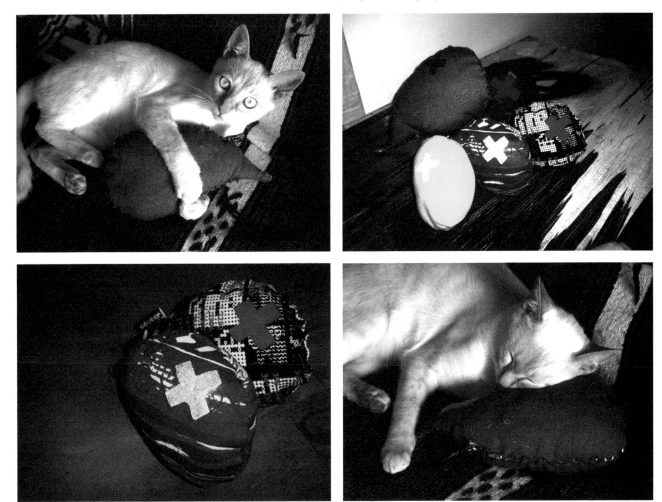

ubicada frente a las Islas Casteletes, con un bajo
grado de ocupación.

Illa de Arousa - Iseña de Arosa ***

La Illa de Arousa es un espacio natural privile-
giado situado en pleno corazón de la ría. En un
entorno casi virgen y poco urbanizado, el visitante
se encuentra con más de 36 Km de costa y 11km de
playas, grandes arenales como Camaxe o Saceda
se suceden con pequeñas y solitarias calas. El
parque natural de Carreirón, declarado reserva
natural por la CE, y el puerto de Chazo son algunos
de los sitios que no debería pasar por alto en el
recorrido por este hermoso espacio natural.

• BELEN GÓMEZ DE LAS HERAS

Guide to Galicia for Carmen, David, Rosa and Adrian

For a trip to Galicia that some
friends and I were planning last
year, I made each a mini guide
with the most interesting places
in the provinces of A Coruña and
Pontevedra. To make the gift even
more personal, the text of the
guide included short sentences that
were specific to each friend.

• | YANINA ARABENA

Written tears

Someone once asked me, "Why not read pictures and look at words?" There are times when what you cannot read says more than anything you can. Could that be why people sometimes stop and stare at writing, trying to read what it says even though they will never figure it out? Here, I fulfilled a need, the need to transmit through a line the range of sensations, emotions and experiences that go beyond anything you can read. That is what motivates me.

LUIS VASSAL'LO FERNÁNDEZ

Electrococo
A series of three mixed CDs (Electrococo, Negrococo, Acusticoco), which I made as a birthday present for Coco. We were out in the country, and the only thing I had to make the CDs was my laptop. Since I did not have a printer, I decided to draw the covers by hand.

LUIS VASSAL'LO FERNÁNDEZ

Music for MOMO
When we first started dating, Coco (who signed her work as MOMO) had me in a love-induced state of ecstasy, and I wanted to show her all the interests we had in common, graffiti, music, etc. I got to work, picked out some songs and started designing her name. I spent the whole night in front of the computer, lovestruck and stroking every letter as if it were a piece of cotton. Just like her.

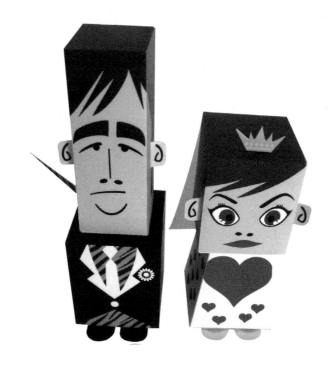

• ALBERT CARRERAS

Bride and groom
Some friends who were getting married asked me for a favor as their token designer friend. "Could you make us a 3D bride and groom to give out at our wedding? You know, for the Spanish tradition where the couple gets up, walks around all the tables and finally gives a bride-and-groom figure to the next couple that'll get married." They gave me some pictures of the couple, so I could see their faces, and since they are friends, I did it. The paper dolls were a total hit, and everyone was happy!

• ANA BUSTELO

Sweet darling
This is a present for my boyfriend. A self-portrait to give him a flower that will never wither.

TVBOY® STUDIO | SALVATORE BENINTENDE

A welfare project for street children in Haiti
"Street Schools" sponsored by the NPH
(Nuestros Pequeños Hermanos) Foundation in
Port-au-Prince, Haiti.

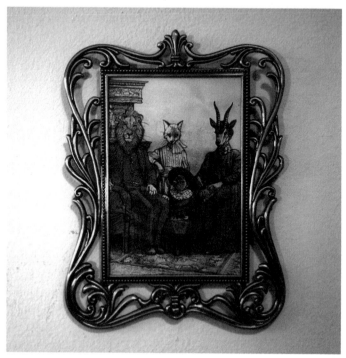

ADOLFO SERRA .

Family portrait
My grandmother keeps a shoebox full of old
photos. Using a picture of my forebears as a model,
I decided to reinvent the origins of my family and
bring them to life. My grandmother was startled
when she first saw my picture but then she said,
"True. We've always been animals in this family."

• ISABEL TRISTÁN

Supersequins
Having people looking at
you. Looking. With a smile,
a touch of inhibition and
good humor... A chat... A
nod to boredom, a "no"
to conventionalism, and a
rush of morality and good
vibrations. The best gift you
could ever give yourself.

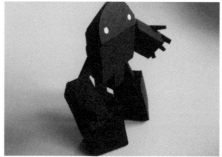
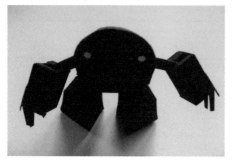
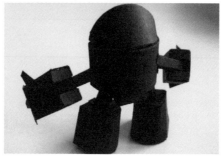

- **LUKE TWYMAN**

Black Card Robot
Designed, in part, to make
Christmas a little different
this year and, in part, to make
the best of limited funds, this
was one in a small series of
handmade, one-of-a-kind gifts
for close friends.

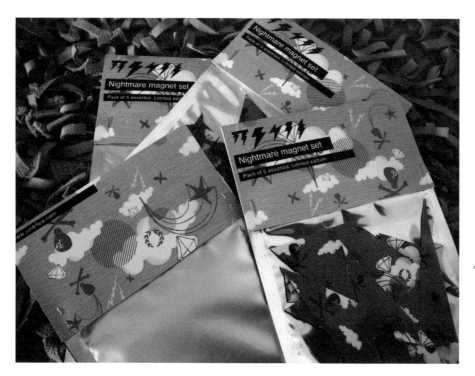

- **AGNES TAN**

Nightmare Magnet
The Nightmare Magnet is a
DIY gift created to beautify
magnetic fridge doors. You
can place them any way you
like, and no two packs have
the same shape or design.

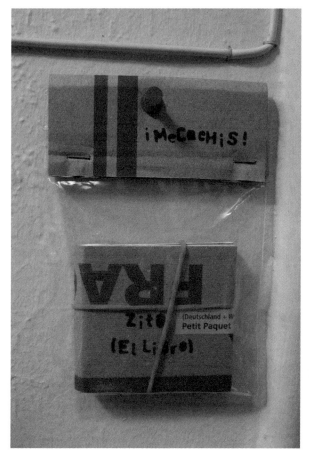

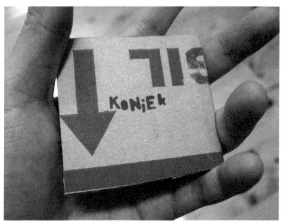

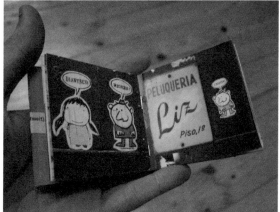

● | DIEGO SANZ ESPARZA

Zito: The Book

After literally hundreds of adventures, the intrepid Mr. Zito decided give his sidekick, Blancucha, a very limited edition copy — the only copy, to be precise — of "Zito: The Book", which describes his journeys through half the world and a fourth of the next.

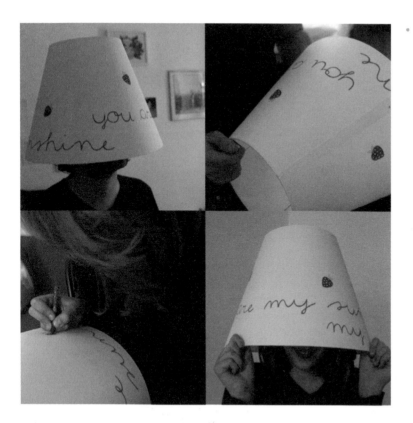

● | SILVIA OSELLA

You are my sunshine
A hand-decorated lamp for a very important person! It has a quote from the song "You are my sunshine", written by Jimmy Davis and Charles Mitchell in 1940 and performed by Doris Day. Materials: One cotton lampshade and pink, red and green wax pastels. Motivation: A lamp is something that you use in your everyday life, and light, like sunshine (and love), is what gives life, what makes it worth living!

● | LAIA CALVET

Casual dins
I met the band "Casual" in 2001, and they changed my life. That Christmas, I gave them a book showing the emotions that their songs evoke in me.

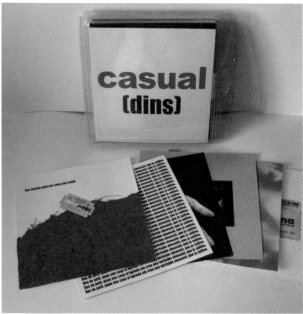

Wonderful T-shirt and the mystery of migration
I made this shirt for my sister's boyfriend, Felip. He is a photographer and TV cameraman, and he did the photos for my web page for free. He is a real charmer, and I wanted to give him something special to say thank-you.

Flying Fish T-shirt
This shirt was for a former student and good friend of mine. He gave me a lot of encouragement and help in selling my work. It started out as an ink drawing, but it faded for some reason (something that had never happened to me before), so I decided to embroider it. I liked how it turned out, and since then, all of the T-shirts I do are embroidered.

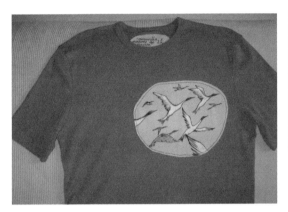

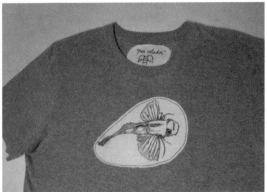

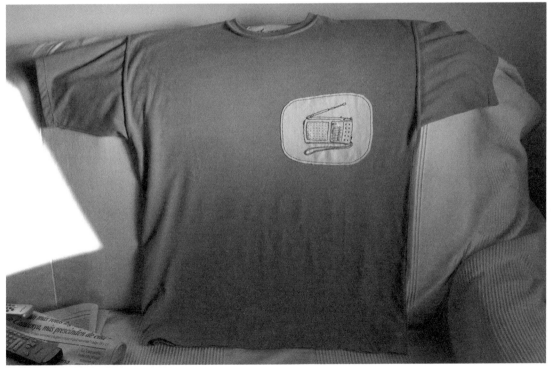

"The guy and I" T-shirt
This was a gift/joke for my boyfriend. He likes to listen to the radio (which I call "that guy") when he goes to bed and when gets up in the morning. That is why I made him a shirt with a radio embroidered on it.

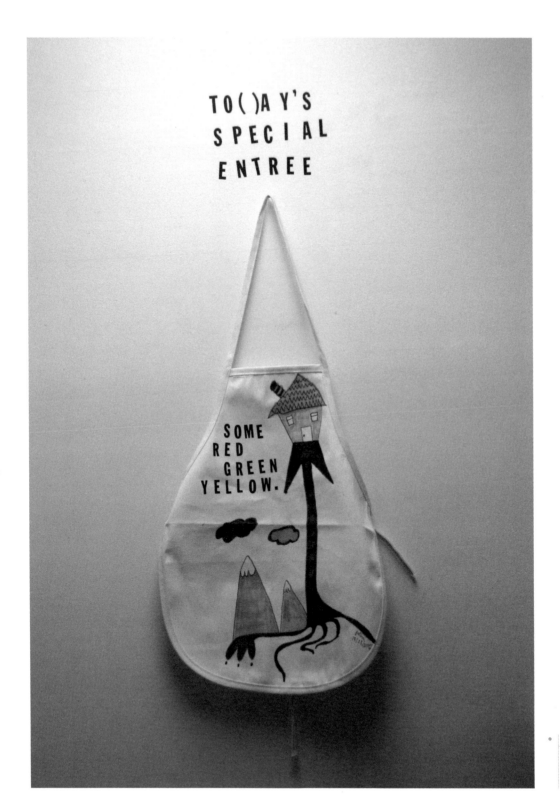

TO()A Y'S
SPECIAL
ENTREE

SOME
RED
GREEN
YELLOW.

PELIN KIRCA

Today's special
A dinner invitation for
a friend.

68

JUST FOR YOU

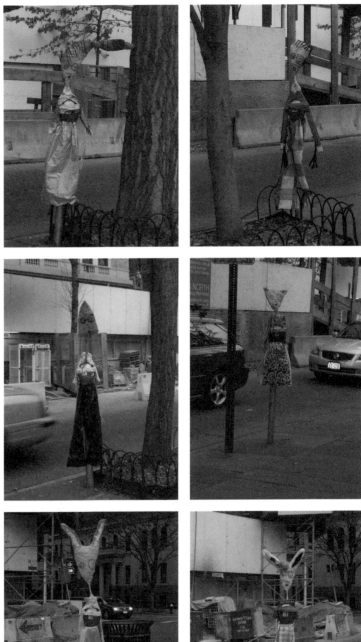

PELIN KIRCA

Touched some
This was a project I made in Stefan Sagmeister's class on touching people's hearts. The idea was to make the inhabitants of Gramercy Park feel happy. One Sunday morning, I put puppets on the park's parking meters.

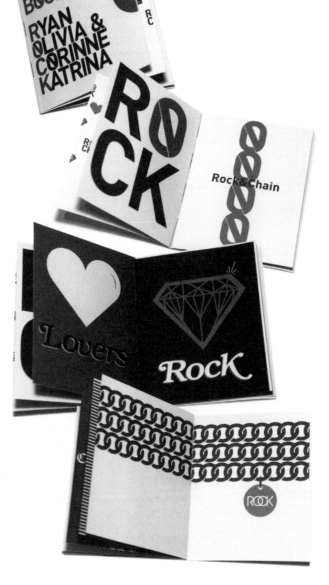

Ryan, Olivia, and Corinne Katrina
A play on of the first letter of our first and last names, illustrating strength, love, and family bonds through the glamour of rock and roll, diamonds, and chain links.

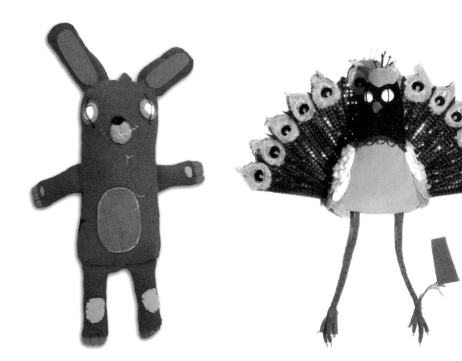

MICHEL NOGUERA | MOG

Animañas
This is our first project together (Namero and Mog). These are stuffed animals that I drew a few years ago, and now, whenever we get together, they take shape in the hands of Namero. From the very moment we started, we were overcome by the feeling that we were creating a great family, and now we are totally addicted!

MARTA DANSA ARNAIZ

A new life for Jan...
My five-month-old son has congenital cardiopathy, and he had to have a heart operation when he was just seven days old. I made a silk handkerchief to say thank-you to the staff at the Sant Joan de Déu Hospital.

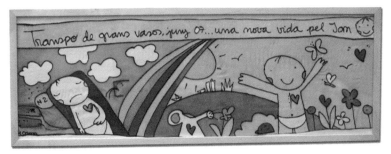

● | GIULIA SAGRAMOLA

Serena's good-luck doll
Another present for my friend
Serena. A hand-drawn collage
girl with a dog and string. She
used to have it hanging up
over her bed.

● | ALBERT CARRERAS

Wedding kit for Iñaki & Marta
Some good friends decide to get
married: "Hey, could you do the
wedding invitation? Not the same
old thing, something cool... I don't
know, with things...like a game..."
"I hope I'm invited to the wedding."
"Of coooourse!" "Okay, to work
then." And several mock-ups later,
the result: "Woah!"

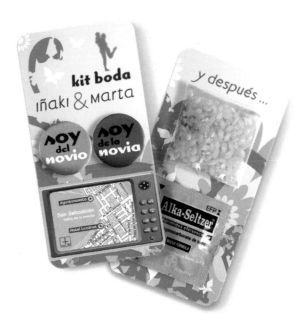

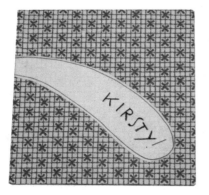

● | GIULIA SAGRAMOLA

Kirsty's mini book
Kirsty is a friend of mine from England. We
usually meet up once a year. Two years ago for
her birthday, I made her a little book. I fashioned
the cover by hand and paginated the book myself.
Inside, there was a little story about how I think
of her every time I see something that reminds me
of the time we spend together. There is just one
copy of the book. Kirsty still has it and took these
pictures for me.

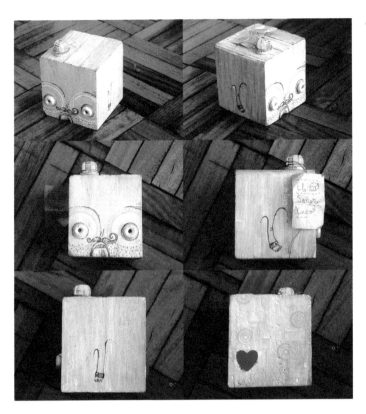

• MARA CAFFARONE

Mr. Cube
I made Mr. Cube as a birthday present for a very special someone, who was there for a very important part of my life. My intention was to show my feelings and let him know that I wanted him to be really happy that day. It wasn't an expensive gift, but I made it with lots of love, so that every time he looked at it, he would remember the intention of the person who made it.

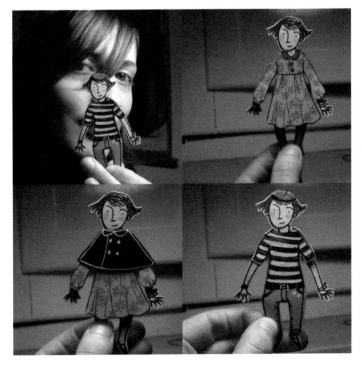

• GIULIA SAGRAMOLA

Paper Doll
I made this project for my friend Erica. It is a handmade paper doll with two outfits, a coat and a little French beret. A unique present for a lovely friend.

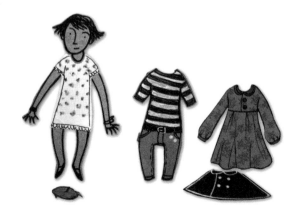

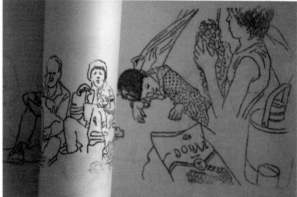

JERNEJA RODICA

From album/Iz albuma
I started making this album for my brother's birthday and filled it with photos from our childhood. Eventually, this intimate book became so special to me that I never ended up giving it to my brother. Instead, I made drawings, prints, collages and an artist book from the photo compositions. An exhibition of this material called "Iz albuma" was later dedicated to my brother and others.

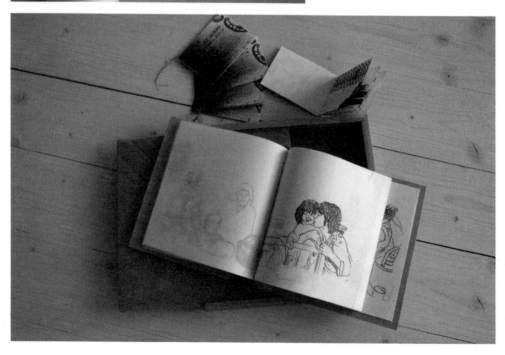

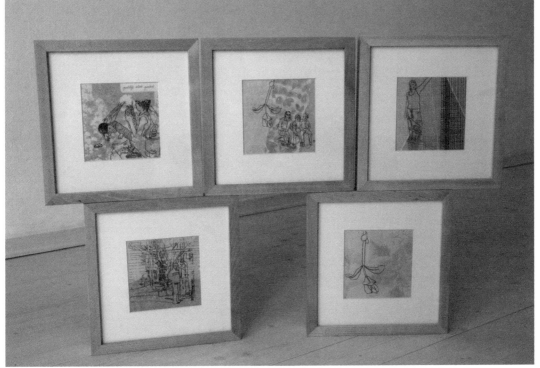

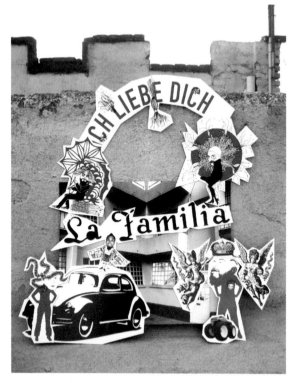

La Familia
A birthday present for my boyfriend Juan Carlos depicting the crazy little things that happen when a Mexican (him) lives together with a German (me).

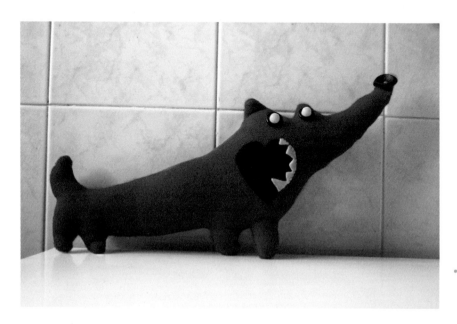

• MARTA MORALES

A little wolf for Angelito
The steppe wolf.

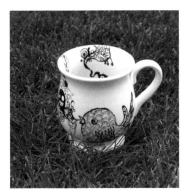
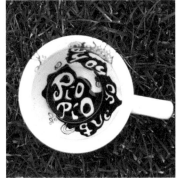
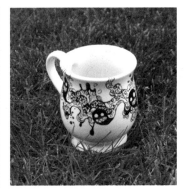

· · ADOLFO SERRA

Peep peep mug
I broke a friend's favorite mug into smithereens. An accident, no, a murder. No such act should go unpunished, so I set my own penance: creating a new mug that would make her smile every time she used it and show just how clumsy I was. A bird that chirps at its demons, "Peep, peep. It wasn't me!"

· · MAMEN MORILLAS

Queen bear, sadist bear and disco bear
Some years back, for reasons that have nothing to do with illustration, I worked on a fashion show and was immersed in a world that was totally new to me. I met some interesting people and had the chance to see them several months later in Paris.
To show my gratitude to these three people (Jean Luc, Sebastien and Patrick), I made each a bear as a small reminder of our time together on the show and an interpretation of how I remembered them afterwards.

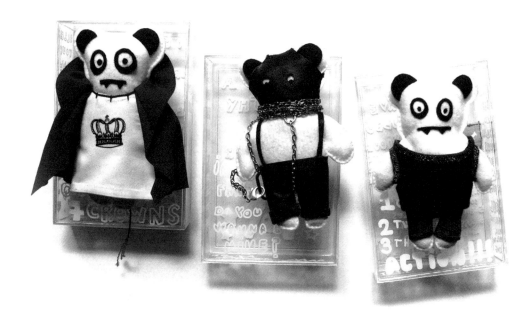

● | MICHEL NOGUERA | MOG

Shoes
Letters and a skull design drawn on fabric with marking pens by our friend Ivan.

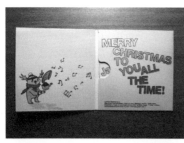

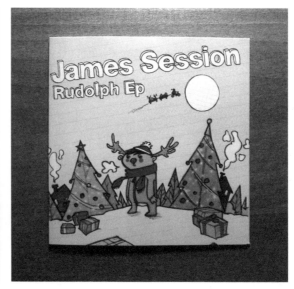

● | CARIN MARZARO

Merry Christmas / Rudolph EP
For me and my band, the James Session, the best and sincerest way to wish our family and closest friends a joyful Christmas was through a song. We made this EP, a gift for everyone from our mums and grannies to our rock 'n' roll pals. We wrote this song expressly as a lovely soundtrack for Christmas (..and the whole year too!) and wrapped it in cute packaging. The "Rudolph EP" was a totally DIY, home-recorded CD. It was printed and fully hand-folded in 50 numbered copies.

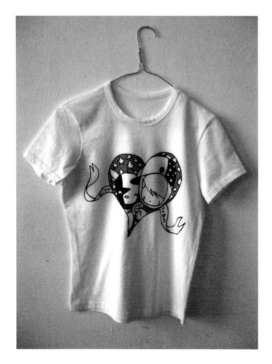

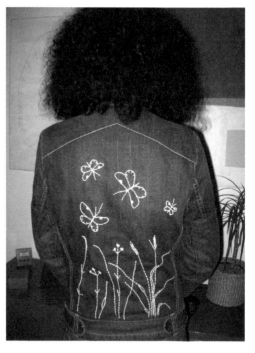

• | TVBOY® STUDIO - SALVATORE BENINTENDE

Love T-shirt
T-shirt silk-screened by hand as a gift for my girlfriend. Valentine's Day 2006.

• | ROCÍO MACÍAS RAMOS

Fluttering Jacket
I made this jacket for my sister's birthday. We were going through a rough patch with lots of family problems, and I wanted to give her something heartfelt and happy. Nothing intense!

• | MARTA DANSA ARNAIZ

My mother is a queen...
I have always drawn queens and though it would be a good idea to shift my drawing to something durable and valuable, jewelry. This is a queen that I designed for my mother. My sister-in-law and father also took part in it.

VANESSA ECKSTEIN

Luka
To commemorate our son's first birthday, we designed a set of pins with everything we enjoyed in childhood. It all came under the word "fly" to express how we felt since he came into our lives.

JOANA OLIVEIRA

Rag Love
Christmas presents for my family and friends in 2006.

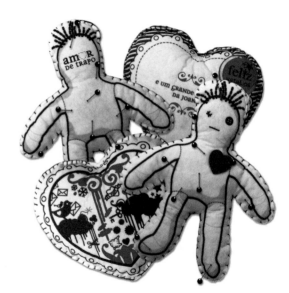

MARK HELTON

PEST FRND Skateboard - Funcie
This piece is about me and the city I grew up in and skateboarded in every day, Muncie, Indiana. I produced a limited edition of 50 decks as a way to reconnect with the skateboarding community.

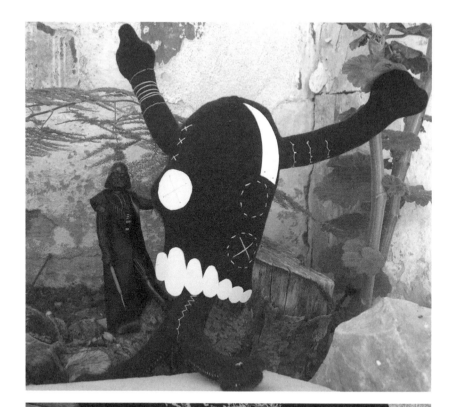

Skullplush
Handmade plush toy for a friend.

A T-shirt with fabric ink and stitching, handmade
for my girlfriend.

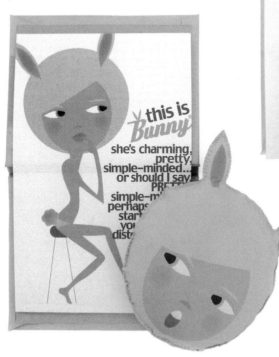

... like wearing high-heels is an absolute necessity coz her Bible* says so.

the Bible also says putting foundation on her clivage would make her boobs look bigger.

*Bunny's Bible, which consists mainly of clippings from Cosmopolitan, Vogue, Harper's Bazaar, etc...

● | TECKHARN KUANTH

Bunny
A storybook created for a slutty and "bimbotic" friend.

● | TECKHARN KUANTH

Anti-whaling
Sign the booklet to stop whaling and save the whales. The idea was to raise public awareness on how commercial whaling can lead to the extinction of whales.

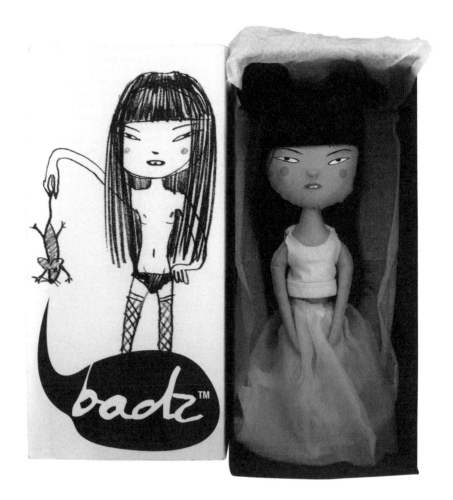

- **TECKHARN KUANTH**

 Badz
 A doll I made for a good friend. The doll basically reflects what she is like as a person: naughty, mischievous, daring and fun-loving.

- **TVBOY® STUDIO | SALVATORE BENINTENDE**

 Welfare project for homeless children in Haiti
 By buying a cup, you donate 15 euros through Nescafé and NPH and make it possible for a street child in Haiti to go to school for a month.

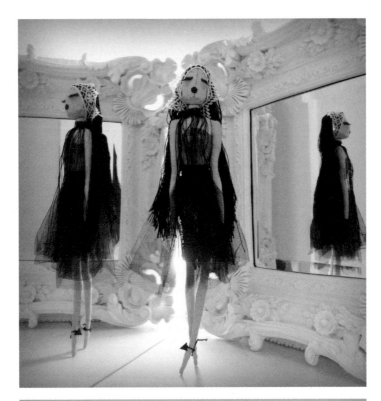

SOKKUAN TYE

Sophie Black Doll
I made my first doll as a gift to myself. Her name is Sophie Black. She looks a bit serious, but she is also sexy and naive.

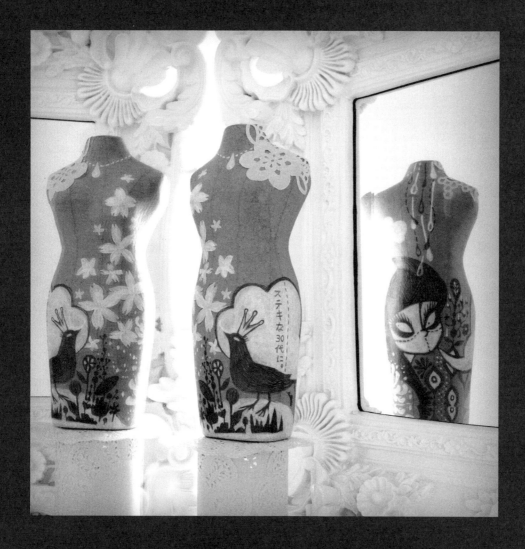

- **SOKKUAN TYE**

For wonderful 30s
I drew Sophie Black on this mannequin as a birthday gift for my best friend, Sling, to wish her more wonderful days ahead as she turns 30.

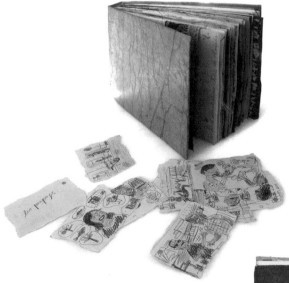

● JULIE DE ALMEIDA

Travel diary

I was going abroad for a year, so my sister and I created a travel diary where I could draw and write down everything that happened to me. Some years later, this book is still one of my best and most vivid memories.

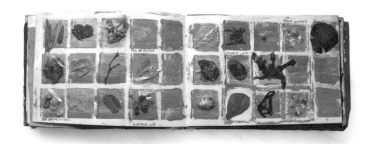

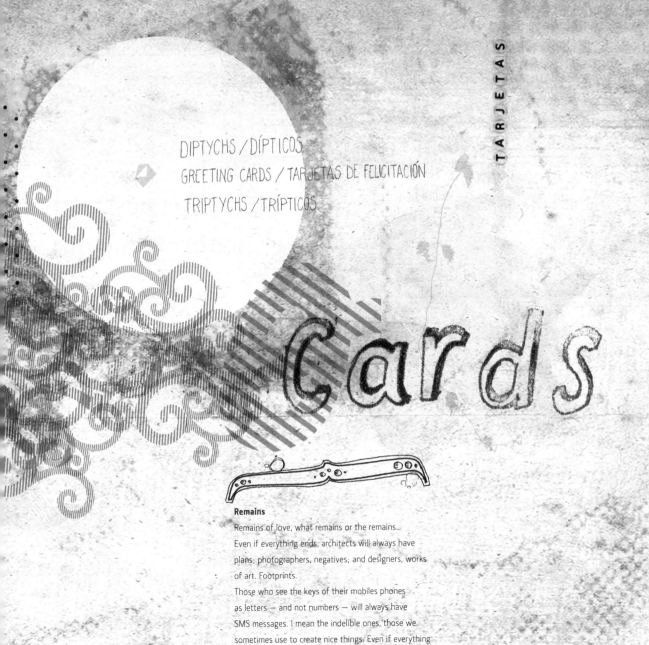

DIPTYCHS / DÍPTICOS
GREETING CARDS / TARJETAS DE FELICITACIÓN
TRIPTYCHS / TRÍPTICOS

Cards

Remains

Remains of love, what remains or the remains…
Even if everything ends, architects will always have
plans; photographers, negatives; and designers, works
of art. Footprints.

Those who see the keys of their mobiles phones
as letters — and not numbers — will always have
SMS messages. I mean the indelible ones, those we
sometimes use to create nice things. Even if everything
is already over, we make it last: signs, demonstrations
of love, remains of what we were.

The other day, I discovered an indelible message in
my outbox. "Look at the story I wrote. I call it 'THEY
LOVE EACH OTHER'. Where are you?", I had asked.
"On the way," came your answer.

Indelible footprints. The thing remains when everyone
takes their own path.

Pablo F.

● LEVESQUE MAXIME

Eliott's Birthday 2007
This is a birthday card I made for my son,
Eliott. (He loves tractors!)

- LEVESQUE MAXIME

Julie's Birthday 2007
This is a birthday card with pictures of our
children for my wife, Julie.

- LEVESQUE MAXIME

Adrien's Birthday 2007
This is a birthday card I made for
my nephew.

Eliott + Tractor
This is a silkscreen poster I made for my son, Eliott.

Denis Christmas 2008
This is a Christmas card I made for my friend Denis.

• | LEVESQUE MAXIME

Denis Christmas 2006
This is a Christmas card I made
for my friend Denis.

• | LEVESQUE MAXIME

Julie Valentine 2006
This is a Valentine's Day card I made
for my wife, Julie.

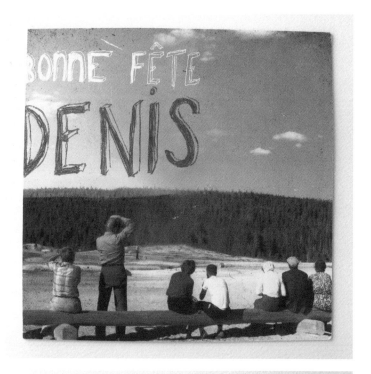

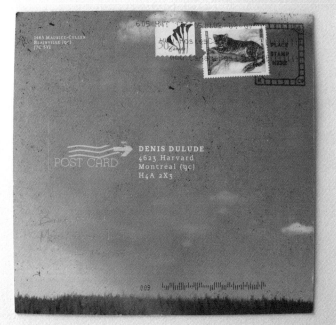

• **LEVESQUE MAXIME**

Denis's birthday 2006 / 2007
These are birthday cards I
made for my friend Denis.

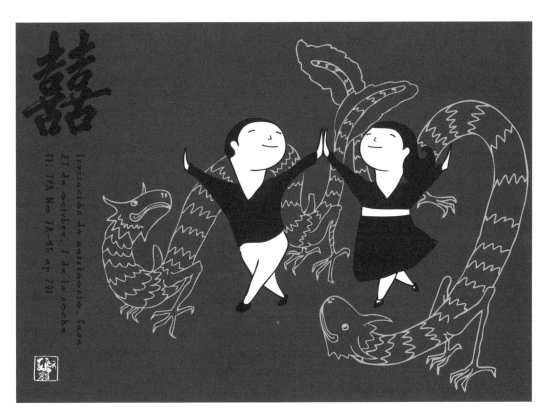

SANDRA RESTREPO

Wedding
We only meant to keep a
memento of our wedding.

• ÁLVARO LEÓN RODRÍGUEZ

Wedding Invitations
For my wedding.

● LEVESQUE MAXIME

Cirque du Soleil Premiere
This is a thank-you card I
made for my friend Denis,
who invited me to the
premiere of Cirque du Soleil.

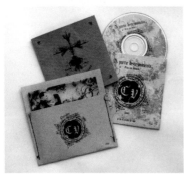

CARLOS RIBEIRO

Wedding Invitation
- Wedding invitation
- Booklet for the ceremony
- Book with the lyrics of the songs that marked our dating years
- CD of songs
- A case to keep everything in

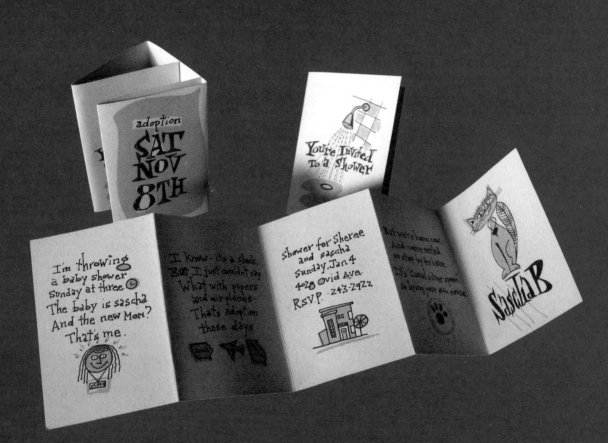

The cards read:

adoption
SAT
NOV
8TH

You're Invited To a Shower

I'm throwing a baby shower Sunday at three. The baby is sascha And the new Mom? That's me.

I know - it's a shock. But I just couldn't say What with papers and air planes- That's adoption these days

Shower for Sheree and sascha Sunday. Jan 4 4028 Ovid Ave. R.S.V.P. 243-2922

But we're home now. And we're settled So stop by the place. It's Casual, silver spoon. So bring your own mouse.

Sascha B

● **JOHN SAYLES**

Sascha's Shower Announcement
When my business partner, Sheree, adopted a cat, she wanted to hold a "baby" shower to celebrate the new arrival. The announcement/invitation I designed for her cat, Sascha, was a hit with her friends!

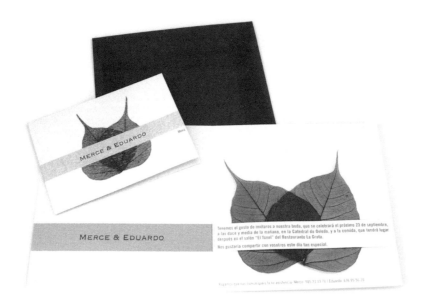

JOSÉ SANTAMARINA

Wedding Invitations
As a special wedding gift.

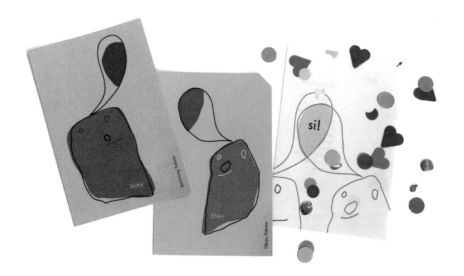

VICTORIA ECKERT

Wedding Invitation
Our friends used to say that we are very stuck on each other. So, to invite them to our wedding, we made two magnetic cards with drawings of a bride and groom by our three-year-old daughter.

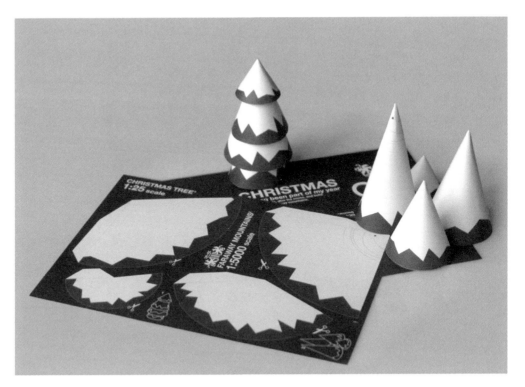

KENN MUNK

Christmas Card
Recipients can cut out the shapes, glue them together and build either faraway mountains or a homey Christmas tree to illustrate the fact that my one-man company operates out of both Denmark and the UK and that I am sometimes close and sometimes far away.

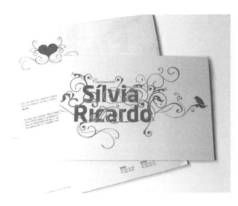

MUSAWORKLAB

Silvia&Ricardo
An invitation to Silvia and Ricardo's wedding.

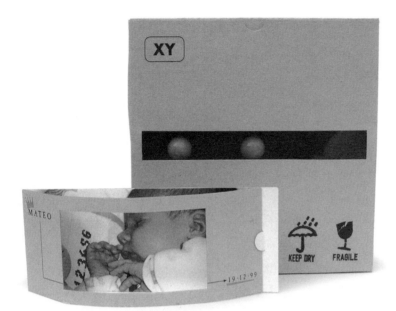

- JOSÉ SANTAMARINA

Birth
A card announcing the birth
of my first son.

- LAURA NOGUERAS

Floor tile
When I moved to a new house,
I wanted to let my family know
that my home was their home.

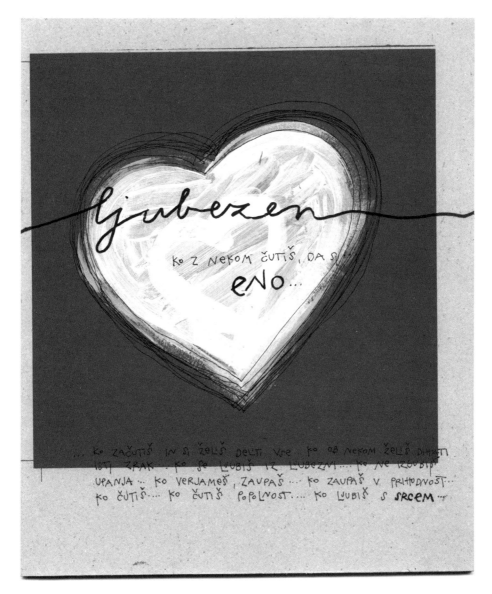

MATEJA OBLAK

Congratulations on your wedding
Love. When you feel with someone,
then you are one.

• DULUDE DENIS

Caroline
A birthday card for my friend
Caroline.

• DULUDE DENIS

Annie 33
A customized iTunes gift
certificate for my friend Annie's
33rd birthday.

• DULUDE DENIS

Annie 30
A birthday card for my friend
Annie's 30th birthday.

bisous
—denis d

● | DULUDE DENIS

Ariane
A birthday card for singer-songwriter Ariane.

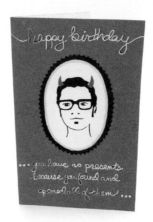

● | MARC S. LEVITT

You make rainy days brighter...
A collage card made with photocopies,
tape and press-on type.

● | MARC S. LEVITT

You have no presents...
A birthday card for someone who had
already opened all of their presents.

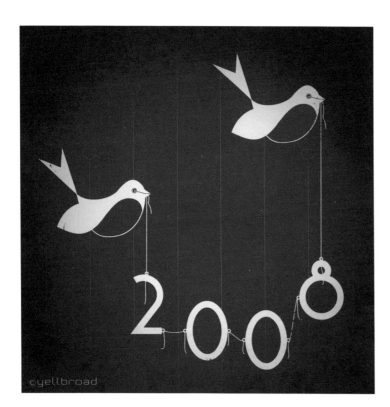

● | EVA RODRÍGUEZ COLLAR | YELLBROAD

2008
A Christmas card I sent to friends and acquaintances.

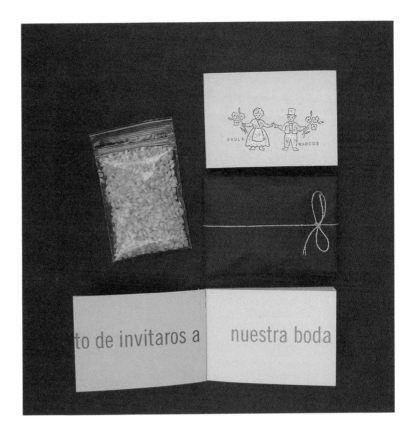

JOSÉ SANTAMARINA

Wedding invitations
As a special wedding gift.

BLANCA GÓMEZ PEÑAS

Ex libris
A friend who likes to read
asked me to make her a
personal ex libris.

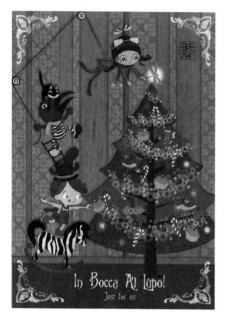

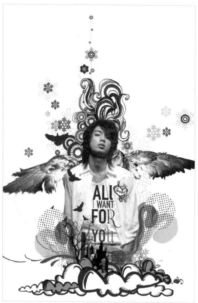

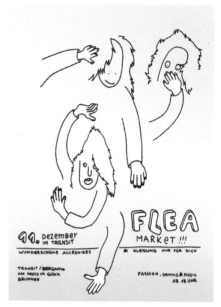

Break a leg!
After two years of hard work, our group LibellulArt was born! We made this Christmas card "just for us" to wish ourselves good luck in our careers as illustrators and visual designers. "In bocca al lupo" (literally "in the wolf's mouth") is how we say "break a leg"!

● EMILIA YAMADA

My gift to you
My friend is a huge fan of this Japanese pop star, so for Christmas, I wanted to give her something she couldn't get anywhere else: a surreal, dreamlike image of her idol. I was really motivated by the project, because I love her very much. We have been through a lot together, and I wanted to say thank-you in my own way, in my own language. .

● CHRISTIAN WALDEN

Invitation/Flyer for a Flea Market
The girls who did the flea market are friends of mine, and I really wanted to do a flyer that was drawn completely by hand. So, I did.

MIGUEL ANGEL MAZON BALLESTER

H+U+G+O
Every year for my son's birthday, we
send family and friends an invitation
to come and celebrate with us. Every
invitation corresponds to a letter of the
alphabet and has a picture of my son,
one year older.

JILAWAN BUNNIMIT

Nebraska to New York
On a trip I took with a dear friend
to New York, I was so aware of
different experiences that
I drew them all, colored them and
presented them in a sewn packet
that I made.

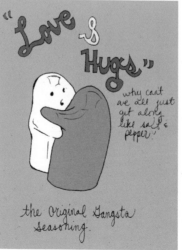

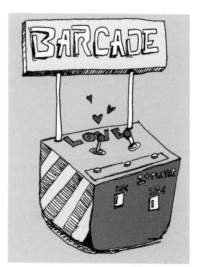

MYRIAM DE NICOLÁS GÓMEZ

Reminder for Anita's first communion

Anita, my niece and godchild, was making her first communion, so I designed this less-than-average reminder. The paper doll's clothes are based on Anita's real wardrobe. I printed a limited edition of 50 for all those in attendance.

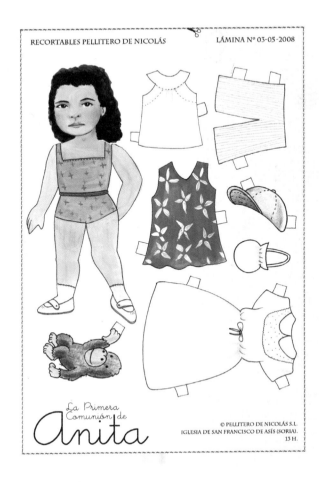

RECORTABLES PELLITERO DE NICOLÁS LÁMINA Nº 03-05-2008

La Primera
Comunión de
Anita

© PELLITERO DE NICOLÁS S.L.
IGLESIA DE SAN FRANCISCO DE ASÍS (SORIA).
13 H.

JULIO BLASCO

Hunches

This was not the first time I did an order like this, but it was the first time that I did it while in love. Each one of the hearts was a little bit of mine. Every title belonged to me. Every proposal was a feeling...

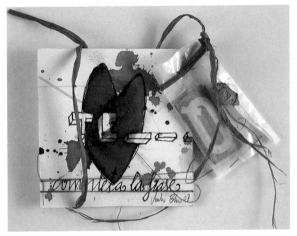

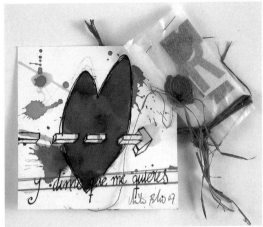

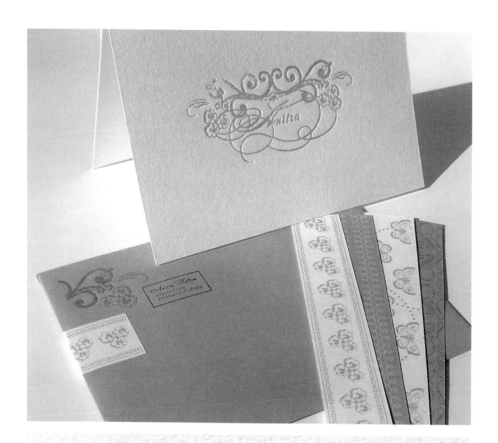

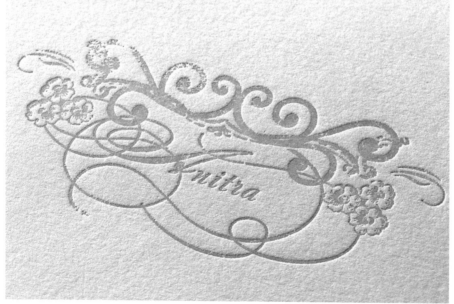

JUST FOR YOU

- **MARK HELTON**

For Anitra
This was a gift for my wife.
I wanted to make her something
personal that reflected her sense
of style and was something
that she would use. So, I made
her a personal stationery set,
including letterpressed notecards,
envelopes, a rubber stamp with
her address, and various labels.

● ANDRES AGOSIN

Together and alone postcard
I designed this piece for fellow designers after observing the paradox of how we all work together online, commenting our work and sharing opinions, but how, at the same time, we are all alone in front of our computers. I took a line from Radiohead's "Kid A" album and mixed it with a hand-drawn graphics and MSN icons to make this small happy, but sad piece.

● | MAJA DENZER

Memory
I used drawings, typography and pictures of Barcelona to make this memory game for my godson. I also sewed him a blue felt bag to store it in.

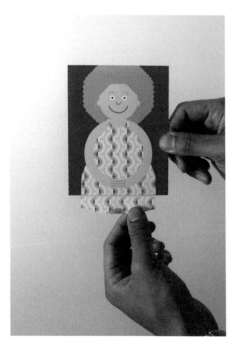

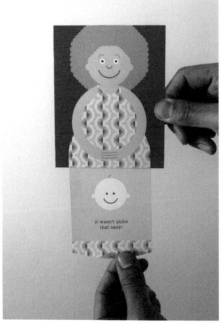

● | PETER PIMENTEL

"Oscar" thank-you cards
Eric and his wife wanted a novel and interactive way to thank all of the people who sent gifts when their son Oscar was born. The receiver (sorta) takes part in a (kinda) birth-like experience.

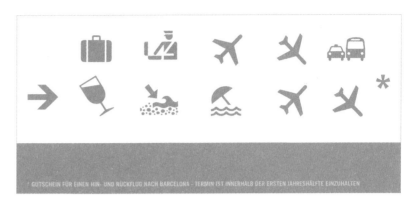

* GUTSCHEIN FÜR EINEN HIN- UND RÜCKFLUG NACH BARCELONA - TERMIN IST INNERHALB DER ERSTEN JAHRESHÄLFTE EINZUHALTEN

MAJA DENZER

Trip voucher
A voucher for a round-trip flight from Cologne to Barcelona that I gave to my sister. The pictographs represent the journey and the things that were awaiting her in Barcelona.

MAJA DENZER

"It's your turn" cards
These cards came with two breakfast kits and a wooden tray (for breakfast in bed), a gift for some friends who were getting married. After the wedding, they were moving in together and would start every day together. Each got five cards to fill out and order a proper breakfast from their spouse. A good way to start a life together!

● CASEY DENBLEYKER

Thank-you Postcards

This fall, I traveled to New York to attend the AIGA 2007 Design Legends Gala. The event was amazing and was made even better by the people I spent time with there. I designed this card to thank them for their kindness and the time they spent with me. The picture on the postcard is one I took at the event. I made the envelopes using pages from The New York times to express a New York theme and really give it a personal touch.

● CASEY DENBLEYKER

Guest Check Birthday Invitation

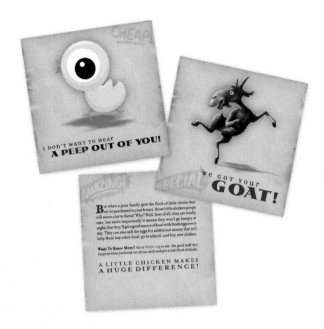

● CASEY DENBLEYKER

Holiday Cards

This year I decided to give several relatives a different kind of gift. Instead of giving them a thing, I gave them the gift of giving to someone in need. Through Heifer International, you can buy animals for families in developing countries to improve their quality of life. I bought several of my relatives a chicken and a goat to give to those in need around the world. I gave each recipient one of these handmade cards and gave it to them when we met to celebrate Christmas.

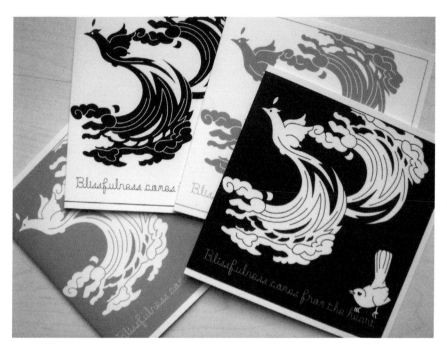

AGNES TAN

Bliss Greeting Cards

Bliss Greeting Cards are intended for the holiday season and bear the message "blissfulness comes from the heart". The design was inspired by Asian woodcarving and modern illustration. I used monochrome colors, so that the cards would stand out from the typical colorful holiday greeting cards people expect to receive.

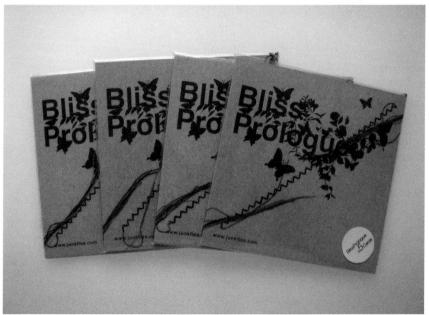

AGNES TAN

Bliss Prologue Cards

Bliss Prologue Cards are intended for people in love. You are supposed to write down your wishes and send them to your loved one. When your lover receives them, he or she can tie them all up and make the wishes come true one by one.

Cards

I always make my own cards for friends'
birthdays, my kids' parties, etc.

ella
imagina
juan josé millás

la
no
via
os
cu
ra

Las oLas
——————
virginia woolf

• **SUSANA BLASCO**

Book club bookmarks
My boyfriend and I have a fabulous book club. We read the same book at the same time, slowly creating sister libraries. I provide the bookmarks, and he brings the wine. These were the first three.

MARTIN LUCAS GUTIERREZ

Loli and Gabriel's wedding
For my sister and brother-in-law's wedding.
A special gift for a very personal couple.

MARTIN LUCAS GUTIERREZ

Juan's Baptism
This invitation was my personal gift for the baptism of my first nephew and godson, Juan. Because this was a special moment for the family, I thought I should use my skills as a graphic designer to make an invitation that was different from the rest. The invitation is bifold in design with a illustration/ collage on the cover. Inside, it has a time line showing Juan's life from the moment of conception to the date of the baptism.

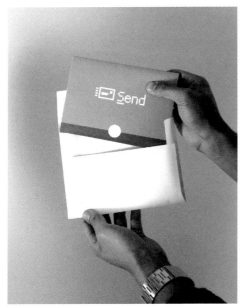
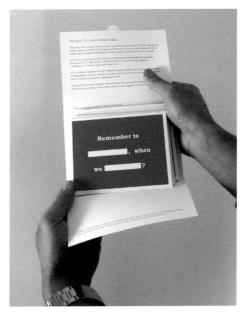

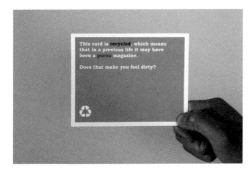
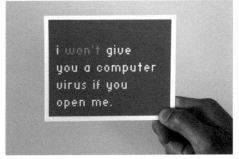

• PETER PIMENTEL

"Send" greeting cards

We wanted recipients to consider the impersonal ways we communicate with each other in the digital age and how rare it is to receive an expressive and meaningful handwritten message. We encouraged recipients to use the enclosed cards to close this gap and get in touch with old friends, colleagues and family members.

- **GERARDO BEZANILLA ORALLO**

Lili

I have always been bad with birthday presents, so when my niece Lili was born, it was like another person on the list of commitments. Somehow, I decided to make the party invitation and added merchandising, street stencils, stickers, rubber stamps, prints, etc. Since then, it has become something of a tradition for me.

- | DANI BUCH BARRIS

The Wedding
Invitations for Pepi and Juan's wedding,
the union of my best friends. I took
pieces of the main image and put them
back together to make the same image.
Screen-printed in 2+1 inks. "Poster" piece
as a wedding gift + invitations.

- | MARINA DOBROV VASILIEFF

I saw him that very night...
When I fell in love the first time, I saw
him and just knew it. I felt it in my body.
A few months later, we started dating.
That was the happiest year of my life.

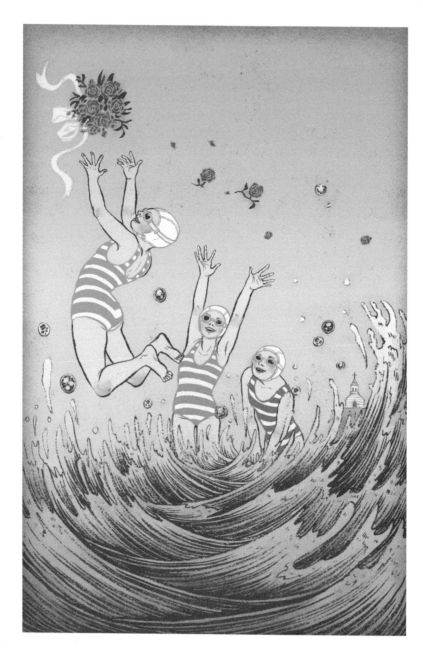

YUKO SHIMIZU

A friend's wedding invitation
A friend of mine had to go back to her home country, Cyprus, when her mother became ill. She decided to have a wedding at a seaside chapel. She had been married to her husband for some time, but they never had a wedding. I gave her this image as a wedding gift. It was designed just for her, someone who is not into the traditional concept of wedding invitations. You can see the seaside chapel in the back.

YUKO SHIMIZU

Big hand-drawn birthday cards
I make gigantic hand-drawn birthday cards for the special people in my life, usually really close friends. Below, there is a photo of my close friend Marcos Martín, comic artist, with the card I made for him right before he left New York to go back to Barcelona.

JONA BORRUT

TO SEE OR NOT TO SEE...
& other post(love)cards

This is a series of love letters/cards in
postcard format that I started developing
shortly after running into someone from
my past, who was very dear to me. (First
impressions apparently DO last.) It soon
became obvious (to me) that we belonged
together. Forever. And EVER.
My task was to come up with a convincing
way to win him over. (He seemed a bit
skeptical of the whole idea, although not
entirely against it either.) I thought: what
better way than declaring your love and
sharing your thoughts the old-fashioned way
on snail-mail postcards? The nostalgia of a
postcard (memories of certain moments and
past adventures) is overwhelming, but
I haven't written on the back of them yet, so
a part of the story is still untold. A little slice
of future is up for grabs. The postcards have
actually morphed into a sort of
never-ending story. I don't really know where
or how to put a stop to it now. Perhaps
sending them would be a good option?

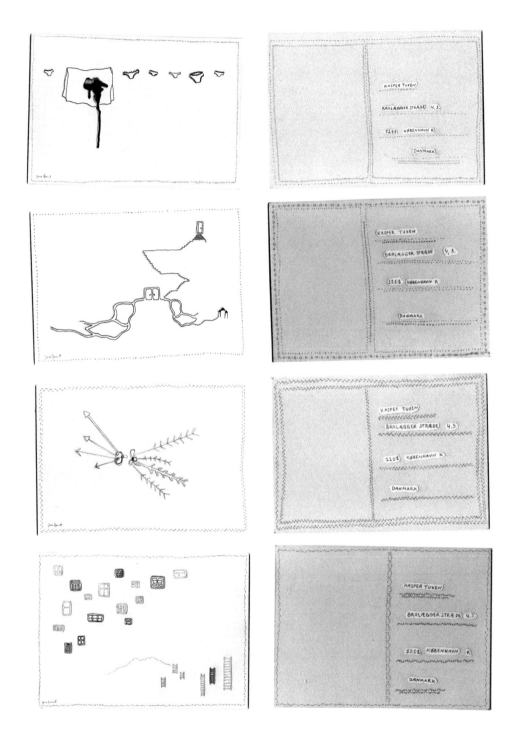

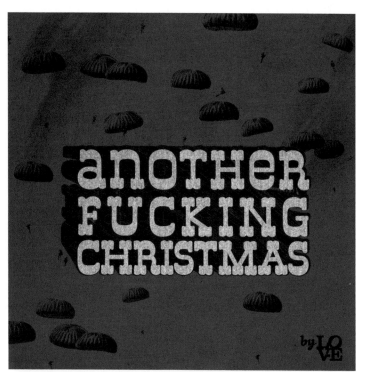

• LORENA VIGIL-ESCALERA

Another Fucking Christmas
A personal Christmas card.

*Winning a Battle, Losing the War

• LORENA VIGIL-ESCALERA

Winning a Battle, Losing the War
I was listening to a song by the
Kings of Convenience with the same
title, and I decided to make up with
a friend by sending this postcard.

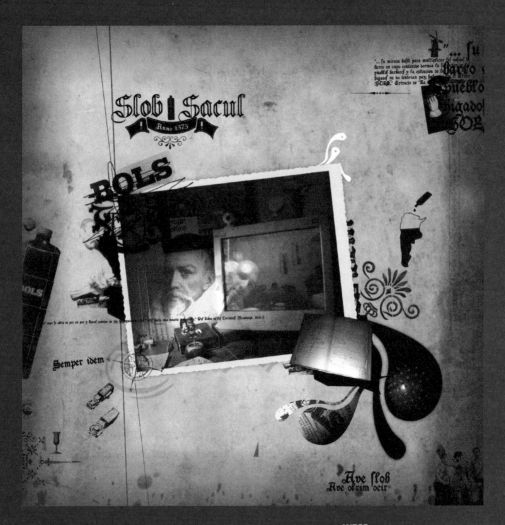

- **WECO**

 Ave Slob

 For the boys of the Slob Sacul
 brotherhood. Love, the ambassador.
 Friends, genever, good music and
 moments that just flow! Ave olnim ocir

It is somehow strange that they asked me to contribute to this book with a text, i.e., a set of words combined, for better or worse, according to the rules of grammar. It is strange for the simple fact that this book is a compilation of irrefutable, authentic and well-documented evidence of situations where words are guilty of negligence. It is full of situations where they were incapable of saying what needed to be said, where they could not fulfil their duty, where they did not know how to communicate what one person wanted to express to another.

Even the most vehement speech or the most extensive and exquisite handwritten letter would not have been enough to make another person feel what these pieces made them feel.

Sometimes words get stuck. They don't come out, or they turn out to be defective, as if they had suddenly become awkward, useless, vain or simply vague. In this text, I would like to use words to admit, however humbly, that no matter how skilled we are at wielding them, there are times when words simply do not know how to be perfect.

Carmen Pacheco

Posters
Logos

ICONOS / ICONS

CARTELES Y LOGOS

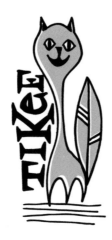

- **JOHN SAYLES**

Tikee Logo
When I adopted my cat, Tikee, I decided she needed her own logo.

- **BJÖRN BÖRRIS PETERS**

TV Tower Sticker
I love the TV tower in Stuttgart, Germany.

- **EVA RODRÍGUEZ COLLAR - YELLBROAD**

Use required
An icon designed for L., a maté tea "addict", for personal use.

- **WECO**

The great Charly!
I designed this logo for a friend who is a huge fan of Charly García (a musician from Argentina). He used it to make a T-shirt.

D. MARTIJN OOSTRA

Declaration of love
I was in love.

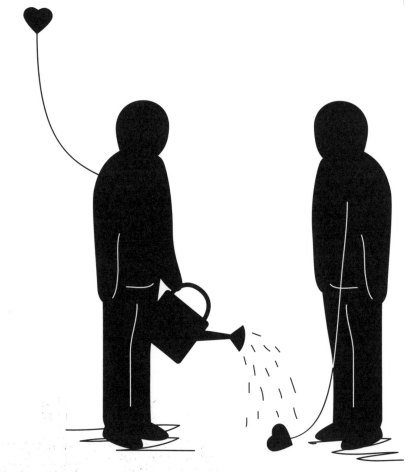

NICOLAS CARACCIOLO

Help others
This illustration is part of a project called "32 tips to keep from dying early", featuring Kurcho, a fictional character who discovered that hearts can talk and is sharing the 32 tips he received from his heart as a demonstration of his discoveries. The tip shown in this illustration is "help others".

YO, KURCHO, MANIFIESTO HABER
COMPROBADO EMPÍRICAMENTE QUE LOS
CORAZONES HABLAN.
LAMENTABLEMENTE SON POCOS LOS QUE
PUEDEN ESCUCHAR A SUS CORAZONES Y
MIS ESTUDIOS INDICAN QUE CADA VEZ
SON MENOS, DEBIDO A QUE LOS
CORAZONES SE ESTÁN CANSANDO DE
HABLAR SIN SER ESCUCHADOS...
POR LO TANTO DECLARO DE URGENTE
NECESIDAD LA EJERCITACIÓN DE LA
ESCUCHA DE NUESTROS CORAZONES.
PARA FACILITAR UN ENTORNO FAVORABLE
A DICHA EJERCITACIÓN Y CON EL ÚNICO
FIN DE ALCANZAR EL GLORIOSO DÍA EN
QUE TODA LA RAZA HUMANA APRENDA A
ESCUCHAR A SUS CORAZONES... GRITO
EXIGIENDO CON TODAS MIS FUERZAS:
LA INOCENCIA, EL AMOR Y LA OBVIEDAD
AL PODER!

kurcho | manifiesto los corazones hablan! escucha a tu corazón

Love

capocha nevada

LO
ve

por nacerme . . .

.. tu primavera . .

- | MARINA DOBROV VASILIEFF

My tree!
My father is one of the most
fascinating people I know. This is
how I think of him.

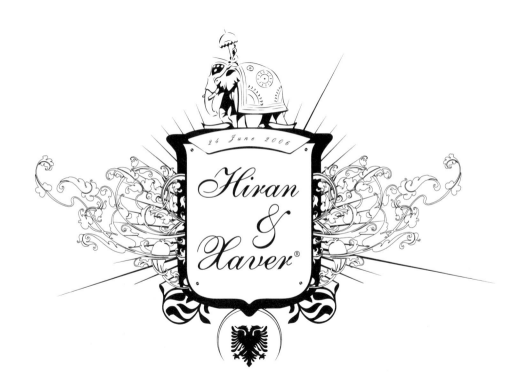

24 June 2006

Hiran
&
Xaver®

● | JOSE PALMA FUSTER | DIGITAL POINT

HIRAN & XAVER

I designed this coat of arms to commemorate the marriage of two friends (she is from India; he, from Germany), and it was part of my wedding present to them. I printed it on a two-meter poster and hung it on the altar during the ceremony.

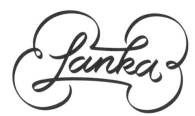

- HENK VAN HET NEDEREND
 OF MOKER ONTWERP

Lanka
A type design to celebrate Lanka,
my friend's dog.

- MARIO RODRIGUEZ

Bea lettering
This drawing was a gift for my girlfriend. It is
basically my interpretation of circus lettering
combined with my own forms. It is kind of
like writing your girlfriend's name in your high
school notebook but taken to the next level.

- MAX HENSCHEL

BlackOut
For the friends of skate, I feel great!

- MAX HENSCHEL

BlackOut
For the friends of skate, I feel great!

• | JOSÉ SANTAMARINA

Illustrations
Various designs to wish a
happy New Year.

● | MAJA DENZER

Book stamp
A book stamp with your name is the perfect way to identify your books. This typographic stamp is more than just the owner's name; it is also a play on words. If you split apart his last name, Herreros, you get "Herr" and "Eros". In German, "Herr" means "Mr." and "Eros" is the same in most languages.

● | TECKHARN KUANTH

The Perfect Couple
I made these wall decorations for a lovely couple, Chris and Karen, for one of their birthdays, so they could hang them in their love nest after they got married.

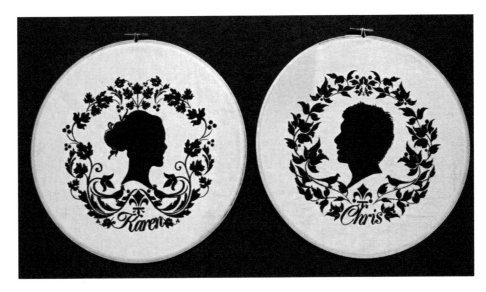

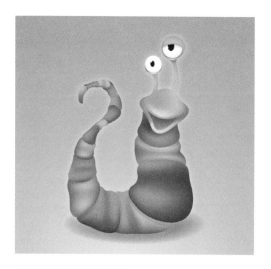

JONATHAN LUIS KICILLOF

Gusamuppet
Gusamuppet is an illustration my friend
Tali's MSN user profile.

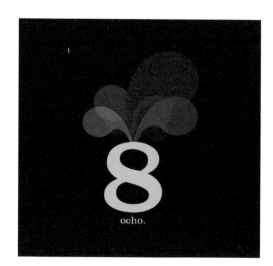

LORENA VIGIL-ESCALERA

Eight
For my eighth anniversary with my partner.

WECO

Our moments
I created this brand image for a very personal album,
which tries to bring together pieces of us, pieces of life!

FRANCISCO PÉREZ MARCO

With heart
Many things are destroyed when a relationship ends,
including the ties and innards that unite them.

· JAUME OSMAN

Gothalans
A T-shirt design for a friend's birthday party.

· JOSÉ SANTAMARINA

Unijoven Club
This piece was done by an eight-year-old boy. He loves football and is a fan of the University of Oviedo team. As the son, grandson and nephew of designers, he got to create a logo that was used on T-shirts, pins and a banner.

· CHAD KOURI

Thank You!
A few friends and I are in an "art family" called "The Post Family". We had a lot of really good friends help us get equipment and move an unreal amount of stuff into a studio space. I really wanted to do something nice for them, so I hand drew some different ways to say thanks and the plan was to send them postcards with the drawings on them. I haven't got around to it yet.

• RICHARD DIAZ FERNANDEZ

Dream of Sayonara Baby

A long time ago, I had a doll. I did whatever I wanted to her. The poor thing had to put up with me painting her every which way, sticking her with all sorts of rings and piercings, dressing her at whim, and donning her with heavy wigs. She looked the best as a geisha, and the costume and makeup for that look took me the longest. Eventually, I named her "Sayonara", and I used to tell her that she was not from heaven or hell, but that she was life itself. This motivated me to do a series of four compositions based on Sayonara's best look. Even so, I'm the true protagonist.

• RICHARD DIAZ FERNANDEZ

The Cupid Lover

I got so involved in the break-ups and make-ups of my friends and family that I started to think of myself as cupid. Many people need the new Cupid, the one who listens and guides you, the one who believes in true love, the one with a few surprises up his sleeve, the one who thinks that falling out of love is as interesting as falling in it, the one who does not hesitate to pierce hearts with his arrows, the one you can all count on. For all of you, a new Cupid is born!

• | MARIO RODRIGUEZ

Kissing logos

This is a series of logos that all have the same general shape. By changing a minor detail (e.g. the shape of the hair or the ponytail), you can change their sexual orientation from hetero to homo or vice versa. I love it. It is like celebrating any type of kiss. The important thing is just to kiss!

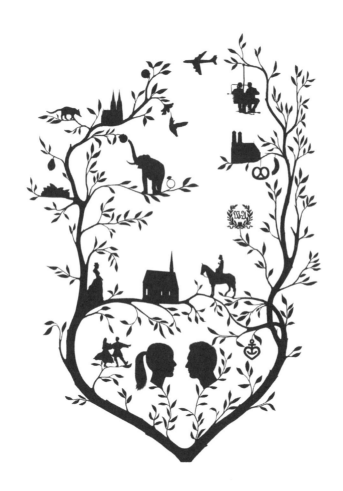

● | SILJA GOETZ

Katja and Sven

This is an illustration for two friends'
wedding invitation. The idea was to
recount the story of their love through
silhouettes hidden in the branches of
a tree. The design came from the bride
herself, Katja Foessel.

MAX HENSCHEL

BlackOut
For the friends of skate, I feel great!

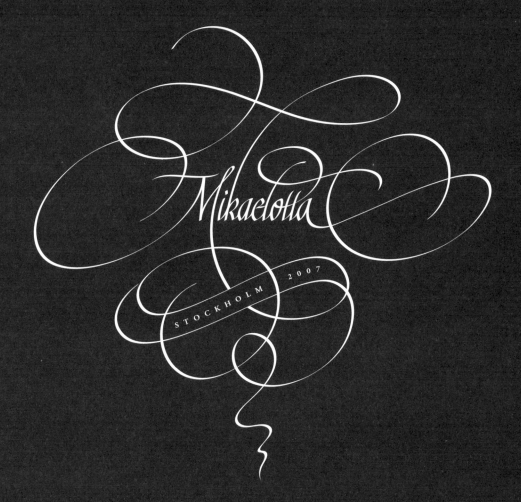

Mikaelotta

STOCKHOLM 2007

● **HENK VAN HET NEDEREND OF MOKER ONTWERP**

Mikaelotta
A wedding gift for my two
Swedish friends.

DAVID MASCHA

Just for you

This is the second installment in a series of posters I made for my girlfriend. Here, I illustrated my name in graffiti-style lettering. My name is my identity, so my feelings and emotions for her are also reflected in this picture. They are depicted as birds, a representation of love.

• | DAVID MASCHA

Just for you
This picture is a poster print for my girlfriend. It actually says "just for you" in a very abstract, graffiti-style letter form. It is probably a bit hard to read, but if you look closely, you will see it. One of the reasons I made this for her is that I know it is not always easy to be with me. Sometimes it is difficult for me to show my emotions, but since I am a creative person, I tried to express my emotions through this picture. The birds in this picture, which represent love, light and weightlessness, are flying through the air but are difficult to catch and to hold on to.

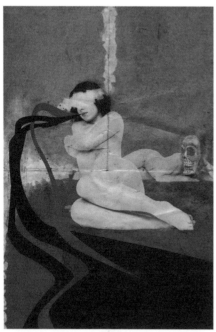

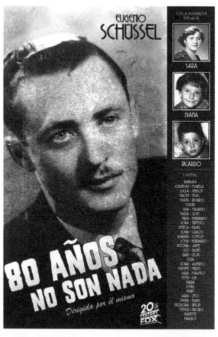

Colonia Las Muertes
Poster to decorate a friend's house, 100% from the heart.

JONATHAN LUIS KICILLOF

80 years are nothing
Poster for my grandfather Eugenio's 80th birthday.

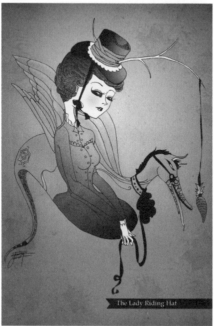

JAUME OSMAN

Scratching your brain
A poster for my friends' rap group.

JOANNE LEE

Hat Girls
For a friend who was madly in love with couture hats. I decided to illustrate a surreal set of two for her.

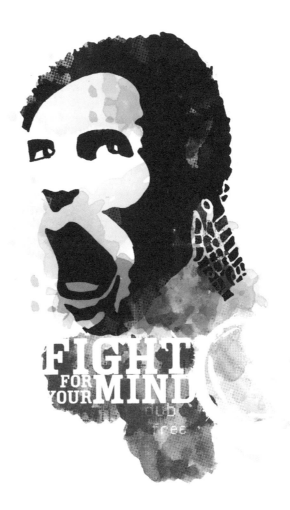

TXEMA MORA

Fight
A present for a friend.

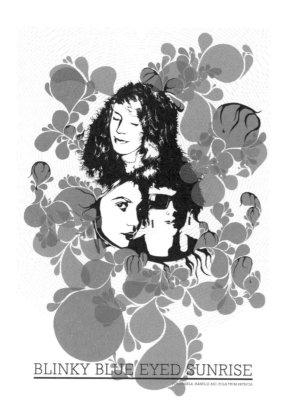

BLINKY BLUE EYED SUNRISE

FOR DANIELA, ISABELLE AND ZOLA FROM PATRICIA

PATRICIA KLEEBERG

Isabelle
A poster for my sister Isabelle and her two roommates to celebrate their first year of independent living and starting university.

MARIO RODRIGUEZ

Punkism
I made this to honor a friend of mine, who is weird as they get!

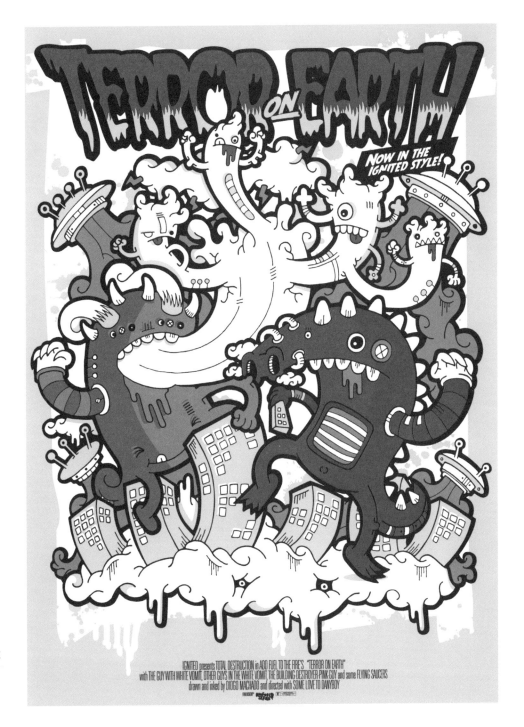

DIOGO MACHADO
ADD FUEL TO THE FIRE

Terror poster
A poster for a friend's
new home

- CARLOS ALONZO CORREA

Pure beauty / tree / JVD
A poster as a gift for a very good
friend.

- ERIC KASS

Rhythm of Recovery
Twenty-five artists from around the United States were asked to create a poster for 25
Above Water, a charity donating to the American Red Cross. I designed and illustrated
this poster to focus on the rebirth of New Orleans, Louisiana and the region impacted by
hurricanes Katrina and Rita.

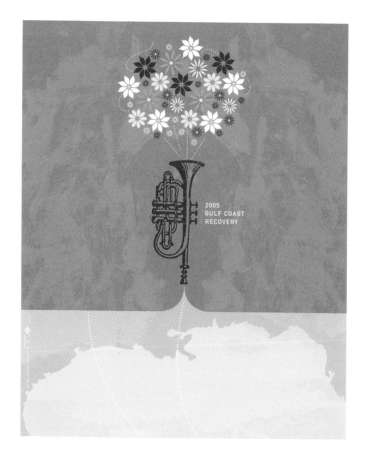

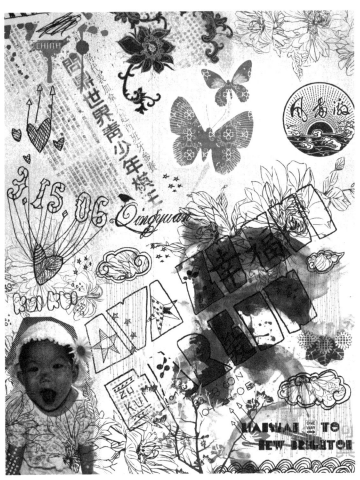

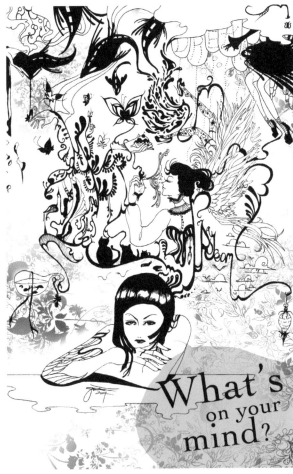

RYAN SEAMAN

Ava

My sister adopted a baby from China this year, so I made a poster about her as a Christmas present. Her name is Ava Zu Kui Larson, and the poster includes sentimental things, such as where she was found, her nickname, the orphanage she was from and assorted other tidbits. If you look closely, you will also find some other personal details. Hopefully, this poster will be around long enough for Ava to admire it one day and see where she came from.

JOANNE LEE

What's On Your Mind?

To clear a depressing artblock, I spent a day drawing whatever came to my mind. I blew the final piece up to poster size for my room to remind me that inspiration is just a thought away.

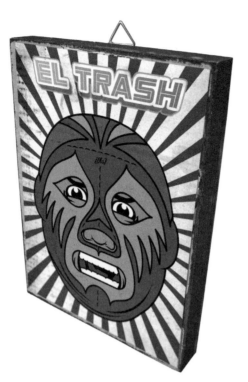

• THOMAS SCHOSTOK

El Trash
A present for friends.

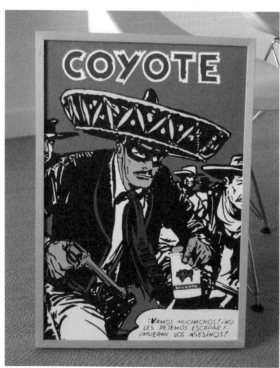

• MATI MARTÍ SAÉZ

Coyote
My love for my deceased grandparents inspired me to make a painting that would help keep them forever present in my mind. I started when my grandmother died. I looked for objects and tried to remember things that they liked or were a part of their life. I gathered some of her personal things with the idea of representing them graphically, but in the end, I only used memories of my grandfather. They were perfect. His COYOTE comic books, which he collected and enjoyed for years, and his BISON-brand cigarettes, which he smoked one after another, were more than enough for a simple composition. I chose an image from one of the hundreds of comic books he had around the house, and I put a pack of cigarettes in his hand. One morning, my mother came for a visit and saw the all but finished painting in the dining room. I was in the hallway and heard her cry out, "Papaaaa!" It reminded her of my grandfather straight away. She looked at it for a few minutes, feeling moved, and then looked at me in silence. When I finished the painting, I gave it to my mother to help her enjoy the memory of her parents.

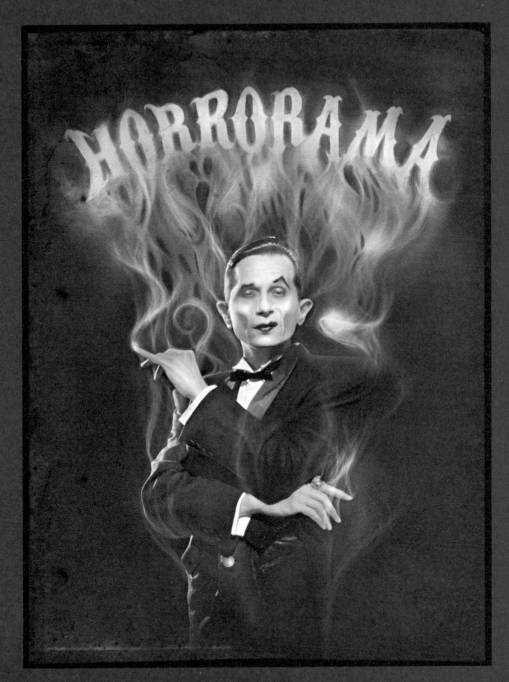

• **GUSTAVO LÓPEZ**

Horrorama
In honor of the great TV series "The Munsters", which I was very
hooked on when I was a kid.

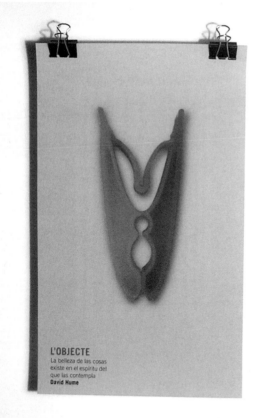

L'OBJECTE
La belleza de las cosas
existe en el espíritu del
que las contempla
David Hume

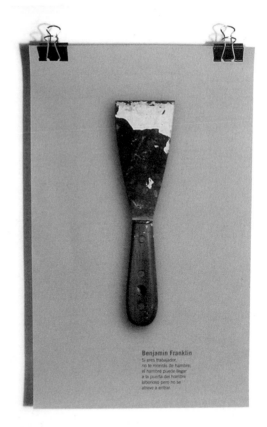

Benjamin Franklin
Si eres trabajador,
no te morirás de hambre;
el hambre puede llegar
a la puerta del hombre
laborioso pero no se
atreve a entrar.

• │ DAMIÀ ROTGER MIRÓ

The Object
This was a birthday gift for a person interested in philosophy. A combination
of graphic design, daily objects and philosophy.

• **JAUME OSMAN**

David Tort
A poster made as a gift for a friend

•• | FRANCISCO VILLA LARGACHA

Tolú street mutts
A tribute to stray dogs.

•• | FRANCISCO VILLA LARGACHA

Polyrhythmic alexandrine about pork rinds
I like pigs very much.

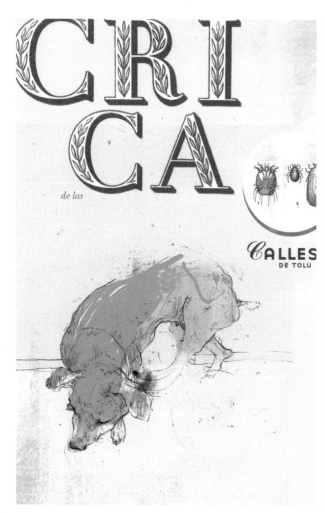

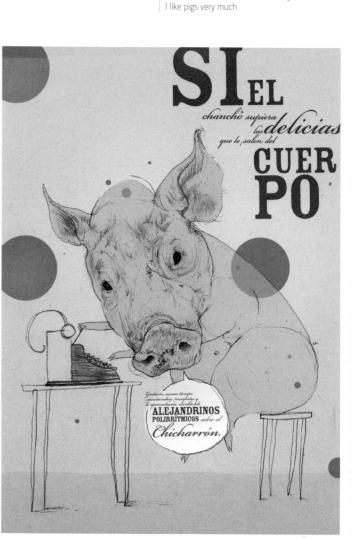

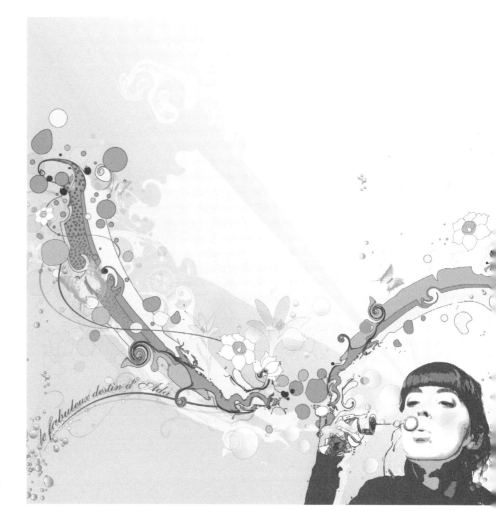

NICO LAURORA

Le fabuleux destin d'Ada
A present for my lovely girlfriend
Ada! "Le fabuleux destin d'Ada".

- JEROME CASTRO | HELLOFREAKS

We love redheads
This piece is a card I designed for the birthday of a friend who happens to be a redhead. Some people feel a bit rejected due to their beautiful but strange red hair color, so the card plays jokingly on that. The text says "we love redheads".

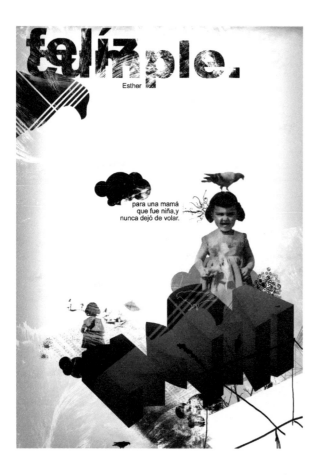

- WECO

The pigeon girl
A poster for my mother-in-law in honor of her 54th birthday.

- JOSE PALMA FUSTER | DIGITAL POINT

Blind
This is a piece I made for my parents to show them the state of anxiety I feel due to series of family problems. I don't want to see this reality anymore.

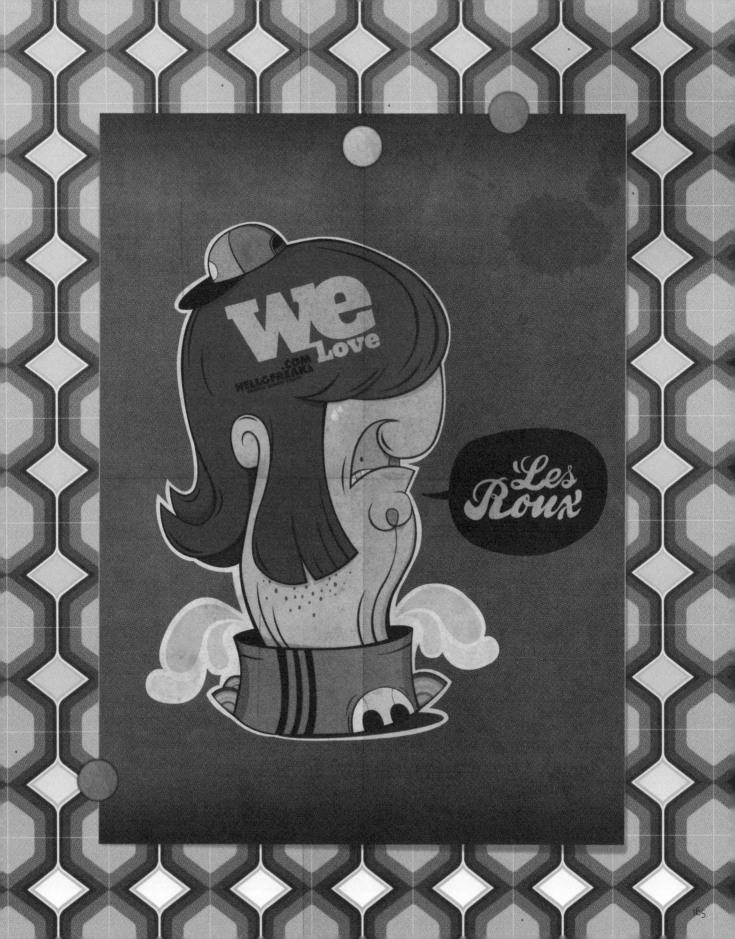

MARTIN ALBORNOZ | BRUSTER

blow 1 + blow 2
This is the interpretation of a pseudo pornographic love directed at her. Technique: screen-printing on wood + markers + acrylic + stenciling. (This was the start of an exhibition project called BLOW®, consisting of 100 wood pieces with 100 different designs for an exhibition.)

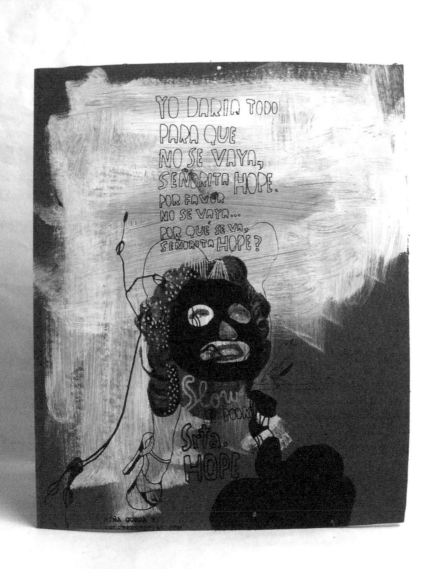

● **MARTIN ALBORNOZ | BRUSTER**

Señorita Hope
A friend of mine was running out of hope. Technique:
screen-printing on wood + markers + acrylic. (This was later
used as the cover of a fanzine. Thank you, Rodriguez.)

ILUSTRACIONES

illustrations

PHOTOS / FOTOS
STENCIL / GRAFFITI

A priori, saying "I love you" to someone close to you is nothing special. "I love you", "I adore you", there are variants to suit every taste. At some time or another, almost everyone has said it, regardless of whether they meant it or not. However, showing it through gestures is somehow different. It requires an affective knowledge that entails sincerity. "Actions speak louder than words" is a worn-out saying that is somehow related to this book's declaration of intentions, apparently pulled together from designs here and there, all altruist in nature and intended to surprise.

If you take a quick look, you will find that this book is actually the result of intimate moments, hugs, kisses, tears, neat looks and love, a lot of love. That is why it does not beat rhythmically; it contains many different heartbeats, each one at its own pace with its own story.

Myriam de Nicolás Gómez

• | ANA GÓMEZ BERNAUS

Sister System

As a gift for my sister when she first moved out on her own, I made these two illustrations to decorate her new apartment. They are a visual representation of the inside world that in some ways, we share as sisters, including our interests, our passions and our dreams.

| LUCILA LIVSCHITZ

Snapshot of Topolina
I made this piece for a small mammal no more than 10 cm long and weighing no more than 100 g, my hamster Topolina. She was a surprising animal, happy and strong, so much so, in fact, that she was able to withstand an operation to remover her tiny uterus (hence the small scar on her belly). I did this illustration several months ago, and now that she is not here, it is my way of remembering her.

| JERÓNIMO ATIENZA ALCAIDE

Rocket ship
A drawing for my nephew, Pablo, an unconditional fan of "roboths", "dinothaurs" and any story containing either (and if they are all mixed together, even better).

| ROSITA ESTÉVEZ

Pussyalien
This illustration came from the surrealistic side we all have. Everyday situations, love, hate, insecurity and uncertainty all thrown together and twirled about.

● | COURTNEY RIOT

More Than a Mouthful

This is a piece dedicated to all my wonderful friends and family. "More Than A Mouthful" was specifically designed as a thank you for my good friend and mentor, Simon McIlroy. He has always said, "Once you settle down and stop growing as an artist, you die." Even though this piece is an extension of my current work, I also feel that it will act as a kick-start for establishing new skills and looks for the upcoming year. At the end of the day, all of my pieces have a thank-you message attached to them. I have been fortunate to be surrounded by the most supportive and encouraging people ever.

Mog Eric Urban / Mog Roy Urban
The orange monster's name is "Big Flip". These were gifts for my friends Eric and
Roy of Urban Underground. They are painted on pieces of wood I find and recycle.

- | BLOHMÉ SARA

Could I be the cloud under your feet?
A small piece for my best friend, Li,
during a difficult time.

- | BLOHMÉ SARA

We are family
A small illustration for Teodor,
a newborn baby.

- | SILVIA OSELLA

My little red flower
This was an illustration I made as a gift for my sister.
I really love her, and we get along very well. She is
probably my best friend! I wanted to tell her through
this drawing that to me, she is like a precious little
red flower, one of those that are difficult to find but
never leave you once you do find them. Plus, in some
Chinese kindergartens, little red flowers are given as
a prize to the smartest and most special kids.

- ## LUCÍA NIES

 ### Hello, Vero!
 A drawing that started out as a greeting for a friend and eventually travelled to Spain to say hi in person.

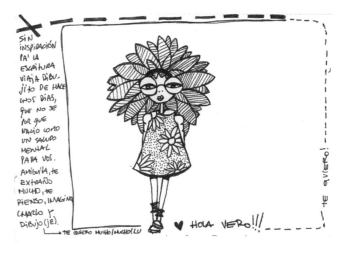

- ## ATTILA BASSO

 ### Viola for Attila
 This is a tribute to Attila's love for Viola, his girlfriend, a tribute my love for my girlfriend.

● | VÍCTOR MANUEL MORAL MARTÍNEZ

Nothing In View I and II
The idea was to depict pirates, a universal subject matter, and print them on
T-shirts for my nephews, Pablo and Andrés, who love adventure stories.

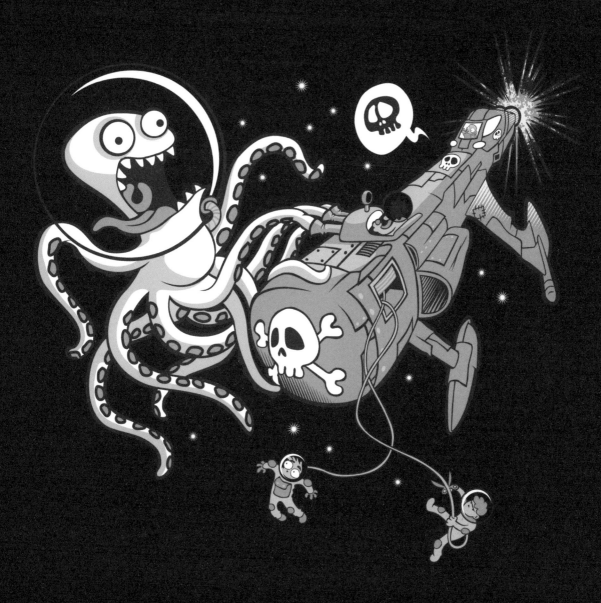

• | DANIEL MARTEL

Gang
A painting inspired by a mascot shared
between a friend and me.

• | ESTER GROSSI

24/08/1974
I found this picture in my parents'
wedding album. 24/08/1974 is
their wedding date. I painted it to
commemorate a special day, their
anniversary.

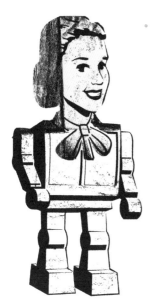

● JERÓNIMO ATIENZA ALCAIDE

Miss Robot
My uncontrollable passion for robots and American pop culture found its expression in this unnatural union.

● PATRICIO OLIVER

The Undead Player
My friend Ignacio wrote me an eerie song that was the perfect representation of a series of characters I was illustrating. Later, for my 30th birthday, he gave me the happy birthday song but done in the style of David Lynch. I felt I had to represent that and return the favor with an illustration inspired by him and his work.

● KENN MUNK

Bollart
As a bit of street-based fun to commemorate the 30th anniversary of the Star Wars trilogy, I altered these probe droids a bit, cut them out of yellow vinyl and took to the streets, sticking them on things and handing out one-inch buttons.

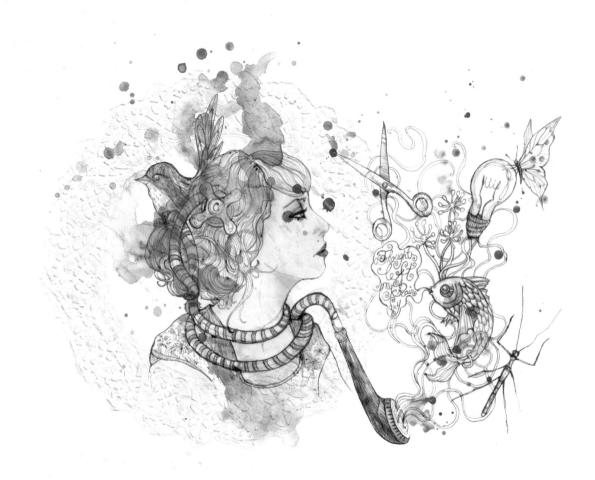

Portrait of a woman named fury
After an absurd argument with my girlfriend, I felt the urge to tell her she was an anger-loving lunatic. Instead I channeled my aggravation into an illustration, "a portrait of her and her wrath". I got to express my insult, and she loved the way I said it.

thank you
mum !

Like an umbrella
This is dedicated to all those
who have helped me in my life,
especially my mom and dad, who
have protected me ever since I was
a child (just like an umbrella does).

OSCAR LLORENS

Universe
A gift for my girlfriend and
our home together.

OSCAR LLORENS

Wedding Invitation
My brother asked me to make him an atypical wedding
invitation, so I made him a 14x17 cm illustration and
printed it on 5 mm lightweight cardboard.

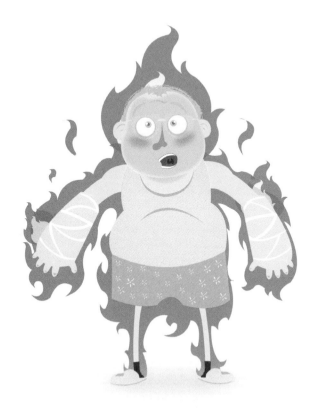

MIKE CASTELLO

My Father in Flames
My dear father had a small mishap when he tried to light the fire for a paella and ended up starting himself on fire. Luckily, the burns were not very severe, and the only thing that truly suffered was his pride when he had to listen to the whole family tell him, "Who let you play with fire at your age!" This piece is my small homage to that ill-fated but somehow absurd incident.

PEDRO COBO CANO

Futuramaniacs
My friends and I are staunch fans of the animated series "Futurama". This gave me the idea of drawing ourselves as if we were part of Matt Groening's series.

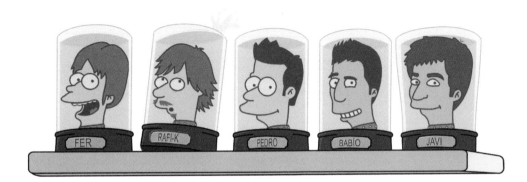

• | JULIETA GUIDICI

Dreamer
The riverbank, the wind, the sun, the sky and the nostalgia for those far-off days
when I was first getting to know a beautiful person, who lived far from my home.

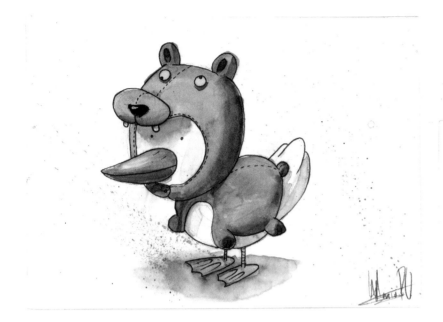

MARIO RODRIGUEZ

Bear duck
This was a gift for a friend who went on an Erasmus exchange in Turin, where it is dreadfully cold. She is the duck.

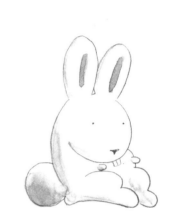

MARIO RODRIGUEZ

Boy with cap
This was a gift for my friend Pablete, who wanted to put one of my creatures in his day planner. It is like a fat version of me.

Birth announcement for Raphael
Raphael is my brother's first child. He was born in May, meaning he is a Taurus.

Birth announcement for Elias
Elias is my brother's second child and was born in Paris. This card is the birth announcement that was printed and sent out to friends and family.

TECKHARN KUANTH

Noody, the Super Dog
An illustration I drew for my lovely super dog, Noody.

JUSTIN SOLA

Canna
A piece designed to say thanks to my girlfriend's parents and wish them a merry Christmas.

BENFOR

Looking like a "little child"
My first trip to London.

BENFOR

AAAAAAAARGHH!!!
The matter of fear. The fear of the unknown
that we have all had to face.

BENFOR

Stop!
The "don't walk" sign used in traffic lights in the USA
is an open palm. I made a character in a harsh posture
with this sign in the background.

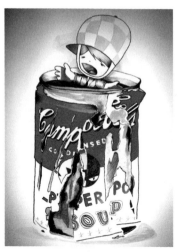

● TVBOY® STUDIO | SALVATORE BENINTENDE

Pieces given to my friends for their birthdays.

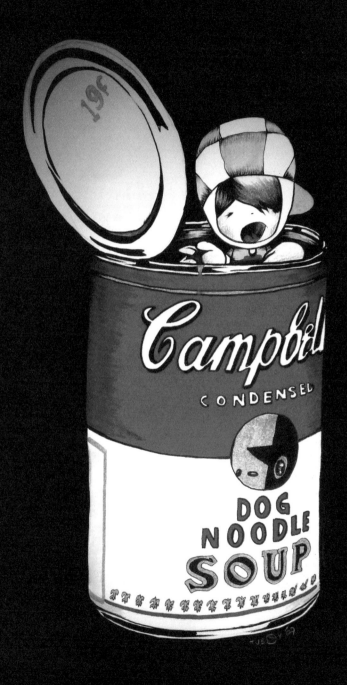

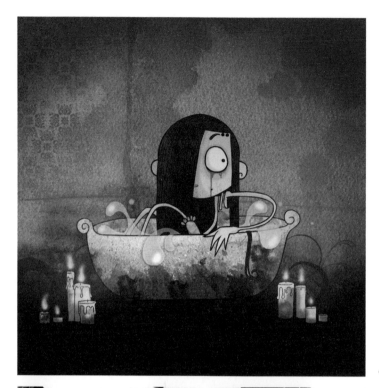

• Princess Gavina

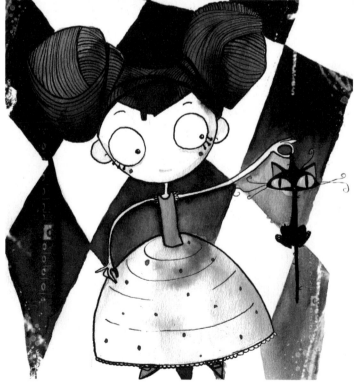

• Princess Bel

These drawings are part of a series of
illustrations that I made for friends for their
birthdays. Each is made in the image and
likeness of a friend but has an added touch
of fantasy.

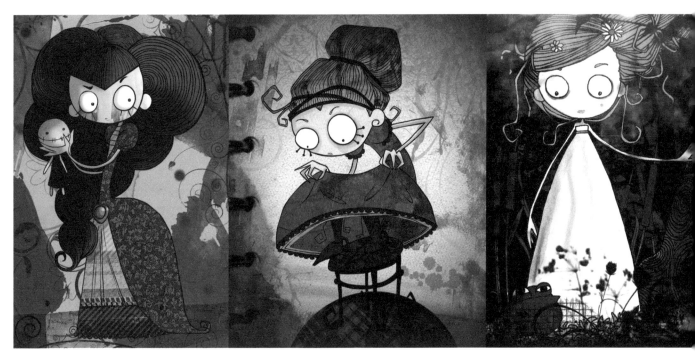

• Princess Elia • Princess Cocó • Princess Toad

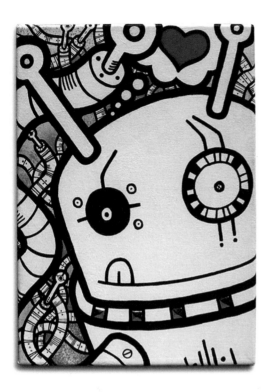

- | DIOGO MACHADO | ADD FUEL TO THE FIRE

A handmade, mixed-media (markers and spray paint) canvas for my girlfriend.

••| MICHEL NOGUERA | MOG

Drawing done by hand 2
A pen and marker drawing (2007) for Zeta, my soul mate. The Chinese characters say "a dream for every night".

••| MICHEL NOGUERA | MOG

Drawing done by hand 1
A watercolor painting/ballpoint pen drawing I made in 2003 at a friend's house in France. I gave it to his mother, who really liked it, and was thrilled to see the feelings it evoked in her.

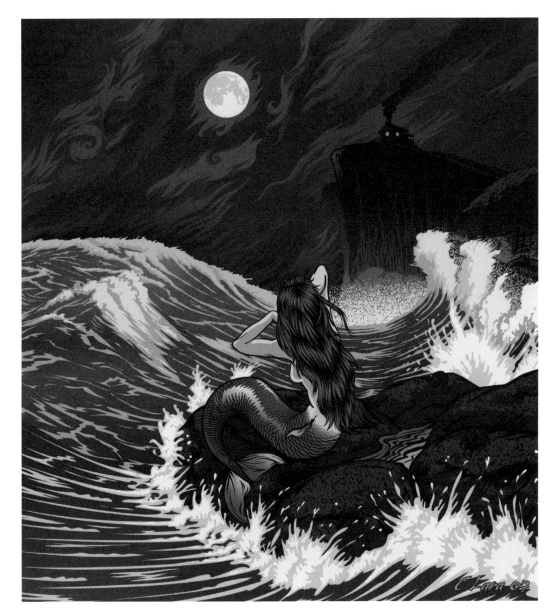

The mermaid
A tale shared with my girlfriend as we fantasized about mermaids and
storm stories. The mermaid is a very recurrent symbol in my life.

○ ELIF VAROL ERGEN

Ex libris
Doing something funny and dark, I think that is the real
me. I am rediscovering myself in my new pieces.

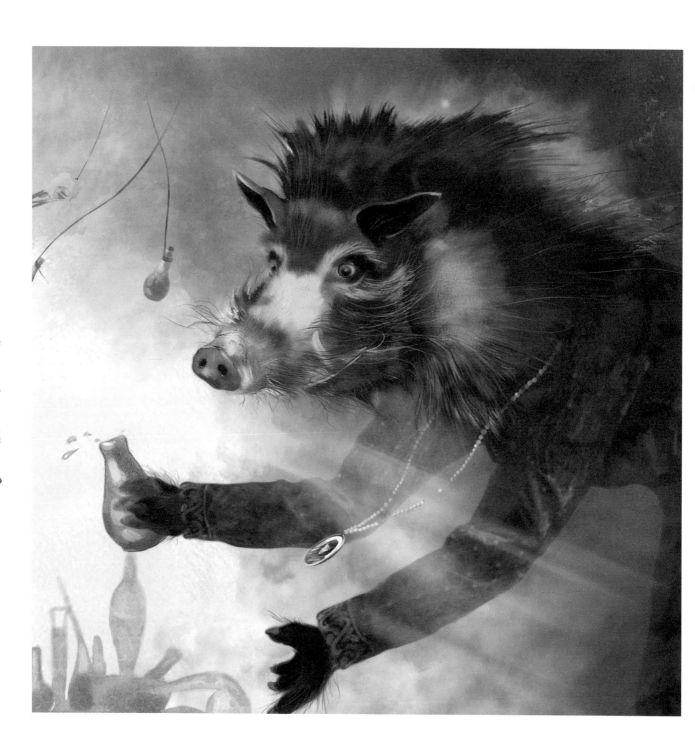

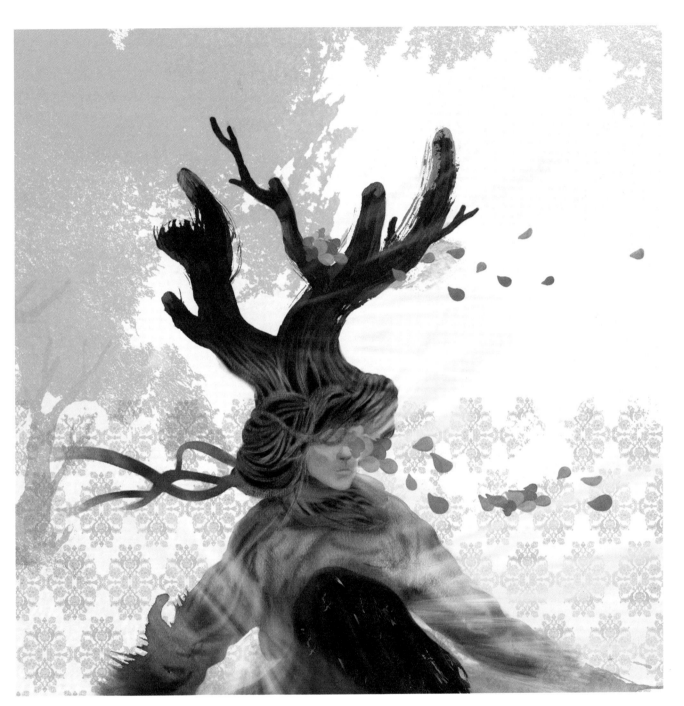

ELIF VAROL ERGEN

The Alchemist's Gift
My motivations are Turkish and Eastern culture, mysteries and children's books.
It also helps that I had written the story before illustrating the book.

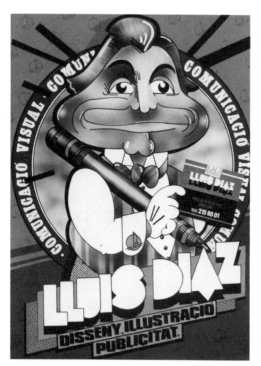

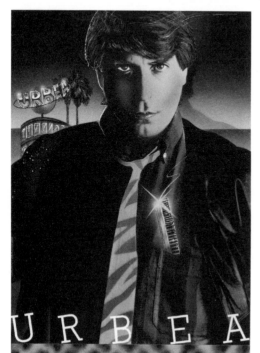

Luis Díaz
This illustration was done by my father, Luis Díaz, in the 1980s. It is not a design of mine, but I am sending it with all my heart as a personal tribute to my father.

Urbea
This illustration was done by my father in the 1980s. It was a gift to a hairdresser friend of his, Josep Urbea.

NATACHA KADHIJA

This piece represents my love for music, which drives me to create and be open to the new styles and references of today's world!

JAUME OSMAN

Syrus
A piece I made for a friend who gave birth to a baby girl.

JILAWAN BUNNIMIT

Seeing the world as it is
Whether walking down the street, riding the train in NYC, or looking at the people across the room, we all tell our own story. I reinterpret the things I see and listen for the sadness, irony and beauty that lies beneath.

JAUME OSMAN

Annoyed
A picture of a friend's face, which I made as a gift.

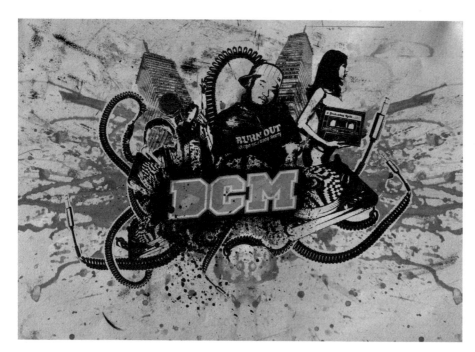

| JAUME OSMAN

Dcm
A piece designed for my
friends' rap group.

| JOSE PALMA FUSTER | DIGITAL POINT

Dumb
This is a piece I made for my parents
to show them the state of anxiety I
feel due to a series of family problems.
It represents the deafening noises
resounding in my head due to the lack of
understanding and communication.

- ### SOLEDAD VÁZQUEZ SUTILO

 #### The Atlantean Worm
 A creature that was born in Atlantis and has the power to make its owner understand the meaning of life. I made it for Marce to remind us both that having each other is the answer we would get from the Atlantean worm.

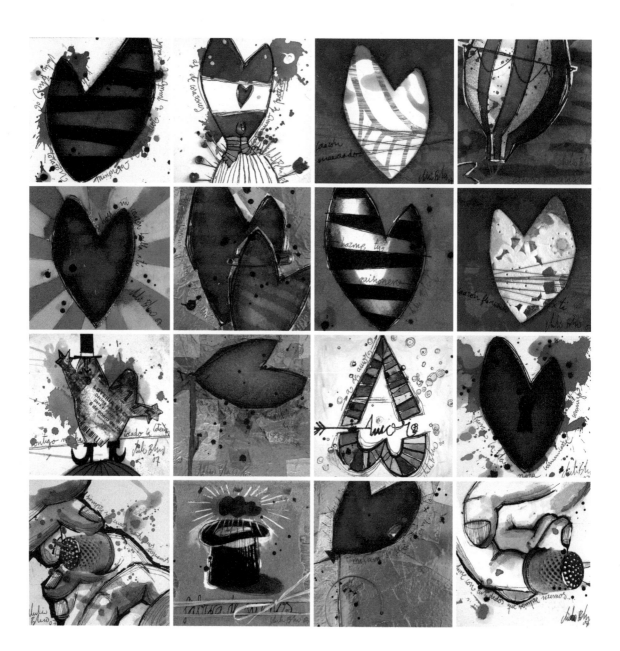

- JULIO BLASCO

Hunches

This was not the first time I did an order like this, but it was the first time that I did it while in love. Each one of the hearts was a little bit of mine. Every title belonged to me. Every proposal was a feeling...

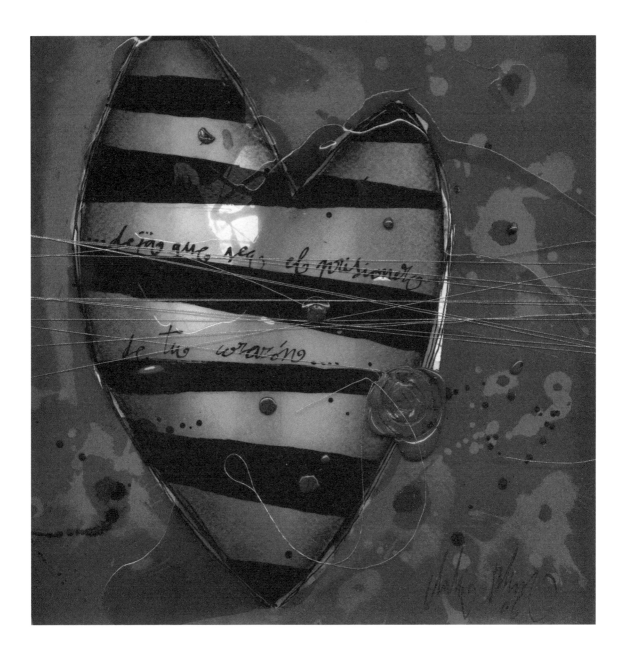

Captive Heart
We met over the web. By the time we went on our first date, my heart was already a prisoner of the relationship. I captured my desire in a drawing, thinking that if everything went well, I would give it to him. Now, it is hanging on his wall.

● | NAZA DEL ROSAL ORTIZ

I love you
I made this painting for an ex-boyfriend
of mine. I painted a wooden box and made
a transfer with this image. I am the girl
in the picture and have a note in my eye
containing a message.

● | NAZA DEL ROSAL ORTIZ

1907
The inspiration for this piece came from
the thought of my ancestors at the
beginning of the 20th century and the
poverty they suffered in contrast to the
aesthetic of obesity in Botero's work.

From a flowerpot

My niece, Julia, was about to turn two, and the toy stores were full of useless pieces of plastic. Why not give her a bit of myself?

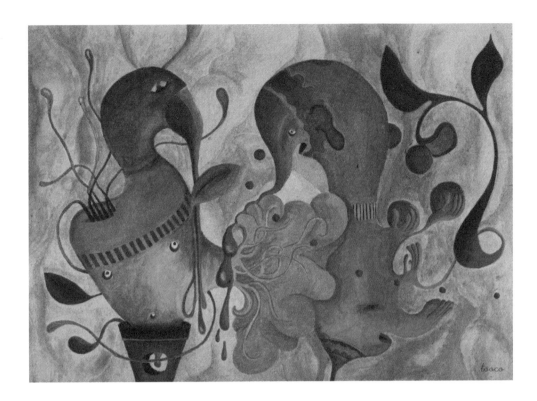

NOEMÍ SAAVEDRA

Au revoir, mon amour!

There are times in life when the butterflies in your stomach suddenly seem to fly away. One day, you discover that their wonderful tickle is gone, leaving you with an empty feeling inside. You resign yourself to it. With sadness in your eyes and tears of nostalgia for a happier past, you bid farewell. "But why are you leaving me?", you ask. Everything seems lost. However, what you don't know is that in the deepest part of you, there is a seed, or rather, a chrysalis. There it is, waiting to be born from one moment to the next, as you cry for what you have lost, despondent and unaware. One day I met a person who was so special that he woke feelings in me that I had all but forgotten. The tiny chrysalis had finally opened! How wonderful! Time stopped for us both. When we were together, there was no one else on Earth. I collected every word from his lips and stored them in a little bottle, so I could listen to his soft whispers at night and fall asleep to the sound of his cooing voice. By then, I had decided that I no longer needed to see this painting; it had nothing to do with how I felt. I gave it to him with all my love to show him that I had let go of the past and would never go back (and because he loved it). Now, I am sad that you aren't here with me.

I need you more than ever. I wish could wake up and see you as soon as I open my eyes, there on my bedroom wall, looking at me, as usual.

MAMEN MORILLAS

Forever in love
From the very moment I met Rodi, there was a special connection between us. It was so strong that we didn't just become best friends; we became blood brothers, each there for the other any time we needed it. This picture is very special to me. I dedicated it to him the day we celebrated the one-and-a-half year anniversary of our fraternal union, and that is precisely what it represents.

MAMEN MORILLAS

While we were sleeping
A picture and poem that I dedicated to one of my best friends, Manolo, on his birthday. Since it was about dreams and dreams are incoherent (or at least mine are), I wrote him some incoherent verses that made reference to our platonic love and our mutual love for food, something we both know how to appreciate. In my verses, he became the salami sandwich boy and I, the chocolate biscuit girl.

● IVÁN REDONDO

CD cover
I wanted to give a CD of music that I had composed. It was quite personal and experimental, standards that I also followed when designing the cover.

● IVÁN REDONDO

iRed discography
The cover for a gift/promotional CD with a selection of my own songs.

● DANIEL MARTEL

2birthday
For my girlfriend's birthday.

● DANIEL MARTEL

Brick wall
A poster I made as a housewarming gift for a friend.

MAMEN MORILLAS

This is a series of four hand-painted boards, which I made for my parents. When they remodeled the bathroom, they bought a new shelf, but since it was made of metal grating, everything kept falling through it. I painted these boards so that my family could actually use their new shelf. The paintings are dedicated to my mother, who was the brains behind the whole operation.

MICHEL NOGUERA | MOG

Mog's world
A mixed-media painting that I made as an internal cry and gave to Namero when we met (2007).

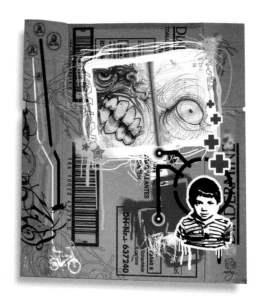

Moorsurf
A T-shirt design for some surfer friends.

Little Big Painting
A little painting for my new house.

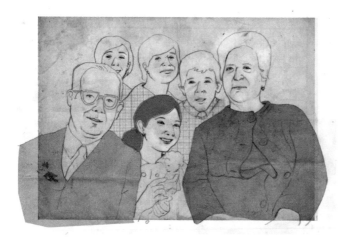

• ANA BUSTELO

Family Portraits
This series of pictures is dedicated to
my family. The drawings are based on
photos from albums and shoeboxes
from back when taking a photo
meant it was a special occasion.

- JOSÉ SANTAMARINA

Pictures
A set of print illustrations on canvas and put together in a frame.

JAIME NARVÁEZ

Little paintings
These are little paintings that I made with the sole purpose of giving them to friends. The first one is a portrait of Silia, an illustrator. The rest do not show anything in particular except for the last one, which I made for a friend who moved to another city.

FRANCISCO PÉREZ MARCO

Raki 02
Raki was the model of a good friend, so I turned her into a stamp.

FRANCISCO PÉREZ MARCO

Jose Luis
Jose Luis is a good friend and the heart of our electro-punk group, "Tamgo" (www.myspace.com/tamgo). I made this as a gift for him in honor of how he screams on stage.

FRANCISCO PÉREZ MARCO

Raki
Raki is a good friend and a great artist. She sent me a picture, and I decided to respond with a reinterpretation in image form.

NACHO MARTÍNEZ BALLESTEROS

Private party fantasy dream
A piece dedicated to a complex world of dreams everyone wants to go to. In this world, desires are combined with different images to produce a fantastic composition.

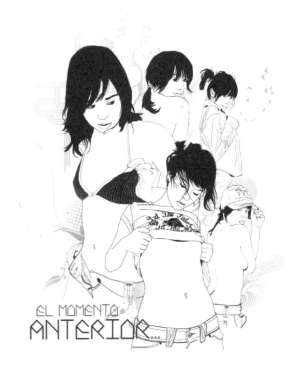

EL MOMENTO ANTERIOR...

NACHO MARTÍNEZ BALLESTEROS

The moment before…
An attempt to capture sexuality the moment before it comes completely out into the open.

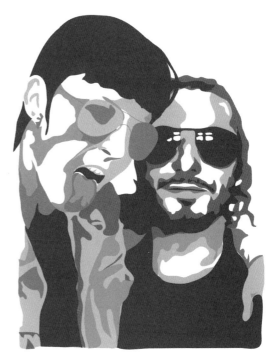

CHRISTIAN WALDEN

R33 - Basil & Sendi
A drawing I did for the guy in the picture to give to the girl in the picture. Sometimes a friend asking is motivation enough, especially because its fun to see your work hanging on their walls afterwards.

ELINA ORPANA

Power animals

In my drawings, I want to bring just one message to the children of the Earth. Shamanism is the world's most ancient healing tradition, curing with the help of animal spirits. Every one of us needs to listen to the wisdom of these spiritual teachers and open ourselves to the knowledge that lies deep within our souls. I hope that everyone can experience the strength and healing that comes from finding their guardian.

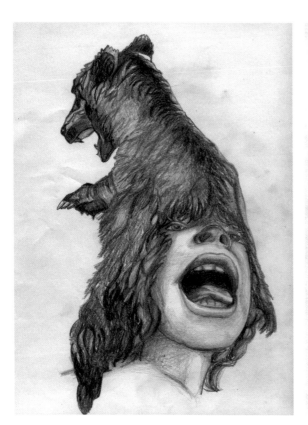

• Brown Bear's Wisdom

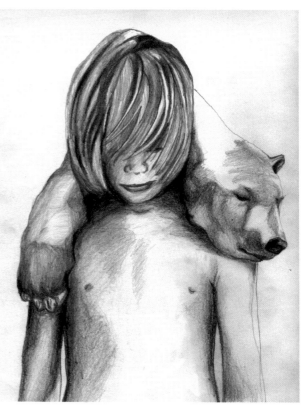

• Polar Bear's Wisdom

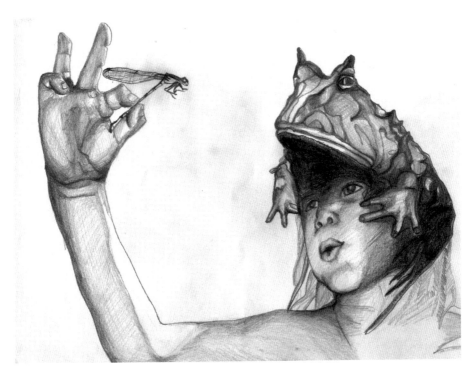

● Frog's Wisdom

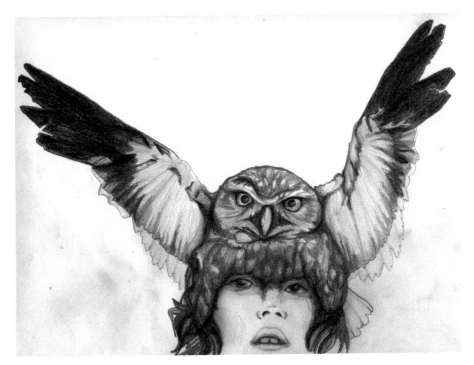

● Owl's Wisdom

- | SARA DELANEY

Commotion / Conversation / Structure
I designed this piece for someone special,
me! After a trip to Seoul and Tokyo, I wanted
to create my own souvenirs. Using my
photographs from the journey, I flattened the
imagery into solid shapes, removed extraneous
details, and collaged images together. The
inspiration for this design was the energy and
commotion of Tokyo's electronics district.

Rumah

"Rumah" means house or home in Malay.
I think this piece is meaningful to me, because
it brings me comfort and joy. Who inspired
me to make it? My family. My parents.

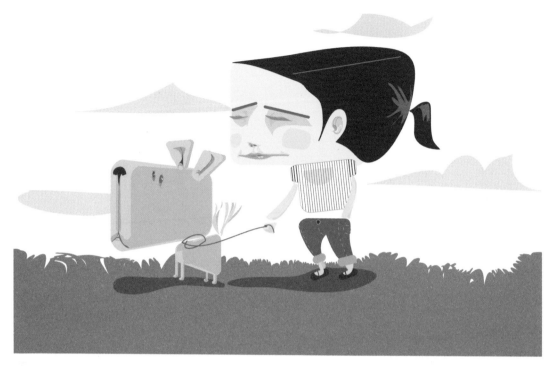

MARIO RODRIGUEZ

Berta and Bambasa

This is a picture of my ex-girlfriend Berta out on a walk with her dog. Later, I gave it to her.

GERARDO BEZANILLA ORALLO

Illustrations for Merienda

In September 2006, Merienda en el Tejando was about ready to open. Its ground floor was dedicated to picture books and children's books, but we thought it looked a little drab. I was going to Japan, but my partner Antonio stayed behind, filling it up with beautiful watercolor and acrylic paintings everywhere you looked.

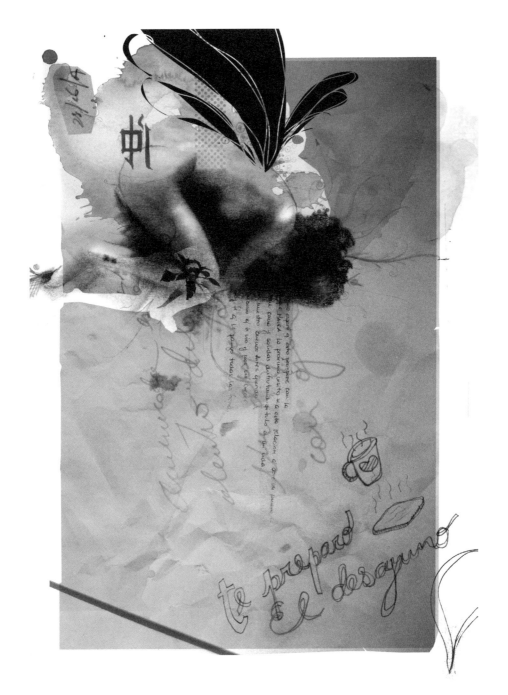

WECO

Curled up
I made this to preserve a special moment when there was no
one else but you and me. And this is what you looked like!

MARIA EUGENIA DIDIEGO

Time

I made this piece to show how, over time, relationships become intertwined with other beings, the time they spend together or the space that separates them, and the work it takes to keep them alive. Then, there is also the aspect of how we not only enjoy them, but actually need them as social beings. When I made this piece, I was feeling inspired by family relationships and the adversities that sometimes keep us apart.

MARIA EUGENIA DIDIEGO

Girl

For this piece, I was inspired by girls, the memory of myself as a little girl, and the burden that being a girl means in our education and development, forcing us to grow up early.

MARIA EUGENIA DIDIEGO

Little time

For this piece, I was inspired by children, by how they enjoy every moment as if it were their last, by their open imagination and abounding curiosity, and by how, as children, they suffer when they do not understand certain aspects of life.

MARIA EUGENIA DIDIEGO

Letters

This is part of a series of pieces based on the passage of time, distance, family and, in particular, women and their place in the world.

Letters II
This piece is dedicated to my Italian ancestors, immigration and the imaginary letters they wrote, talking about
their new lives, how much they missed their family and country, and how difficult it is to be far away from home.

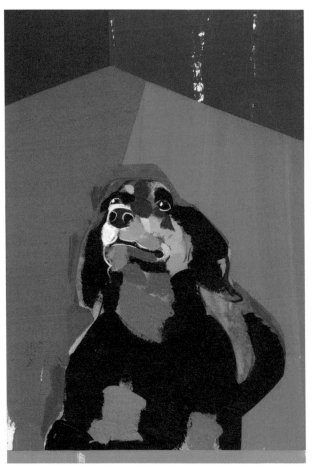

| ILANA KOHN | ILANA KOHN |

For Mom

My mom was the motivation! She wanted a painting of our dog, so she got it. This was sort of a belated Hanukkah, "sorry I fogot your birthday" present.

A Painting for Ernest

I made this painting as a gift to my wonderful friend Ernest. For a long time, we had been planning on creating special, one-of-a-kind works of art for each other—not just a "trade," but something made with the other specifically in mind. We are great friends and have been inspiring and supporting each other for as long as I can remember. Our relationship means a lot to both of us, so it makes perfect sense that we created these pieces for one another. I have to say, the painting I received from him is amazing. It is hanging right over my desk and inspires me every day.

● | DAVID DE RAMON GUTIERREZ

Carlota
An announcement proclaiming the birth of my daughter to family and friends.

● | ILANA KOHN

Wedding Gift
I made this painting as a wedding gift for my friends Ian and Pilar.

● | FRANCESCA TESORIERE

Newspaper
I saw my sister sitting just like this, reading a magazine.

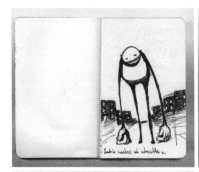

FRANCISCO LOPEZ NUÑEZ

Whatever comes out of the Pilot
These are illustrations I made with the left half of my brain. They were totally free with no concept; I did not even know what I was going to draw until a few lines were already on the paper. I was literally squeezing out what was in my head through ink and directly onto the paper. I usually do this when I am travelling, and in truth, I think it is my freest and most honest work. Just me, my black Pilot pen and my notebook. Nothing else matters!

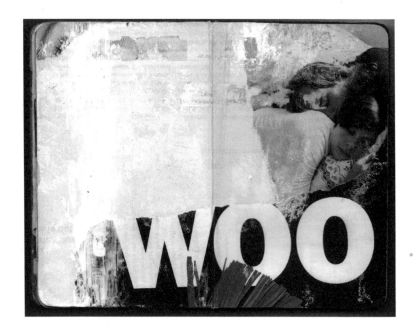

SEBASTIAN WATERS

Do you just wanna play?
This is a collage I made in my first gluebook for a very special girl after our first dates, using acrylic colors, snippets and cutouts from magazines.

RAIDY MARIEJOE

Oysters

A book inspired by the private stories of several Lebanese women, all collaged into one publication. The submissions are excerpts from that book.

MARIO RODRIGUEZ

Brother

My brother and I slept in the same room for 21 years. When he moved out, I painted a portrait of him sleeping as a gift to celebrate his newfound independence.

Illustrations/Gifts
A series of illustrations used
to create cards, which I later
gave to clients and friends.

JUHA FIILIN

Moomins/Pianist
These are people and animals I saw out on the Finnish countryside. Everything happens in the middle of nowhere in the forest in a bar where people who are waiting for the final judgement come to meet.

Life in Ban Pho
A vision of a girl in her
environment, in the village of Ban
Pho in the Sapa region of northern
Vietnam to be precise.

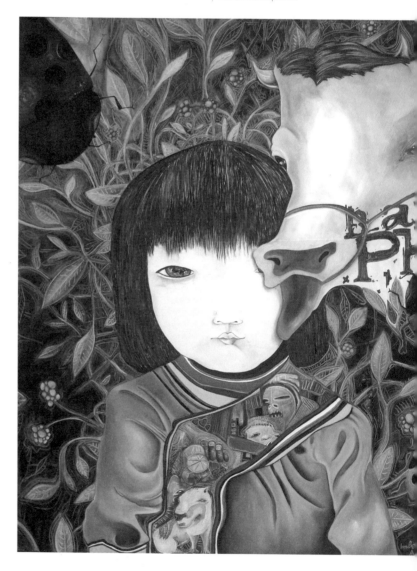

The saleswoman
I found a girl in Cambodia who was selling live or fried tarantulas, depending on your taste. In this version, she is selling a different product.

Creature I
A mixture of what can be seen plus a little bit of fantasy.

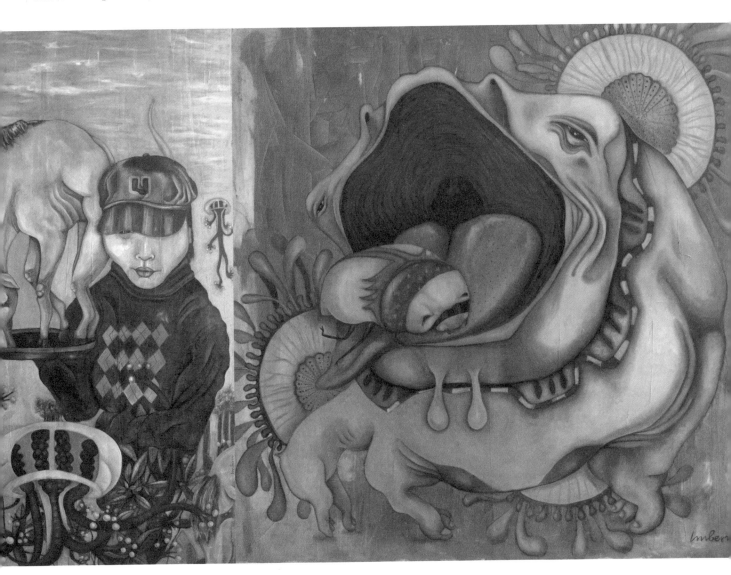

estius a la Vola

La Vola
A friend's birthday. Every year, a group of friends and I share a few days at this incredible place in the Osona region of Catalonia.

rambla de catalunya

Egge's Rambla de Catalunya Card
In 1986, we moved to a small studio apartment on the Rambla de Catalunya in Barcelona, a moment captured in this illustration, which we later gave to our friends.

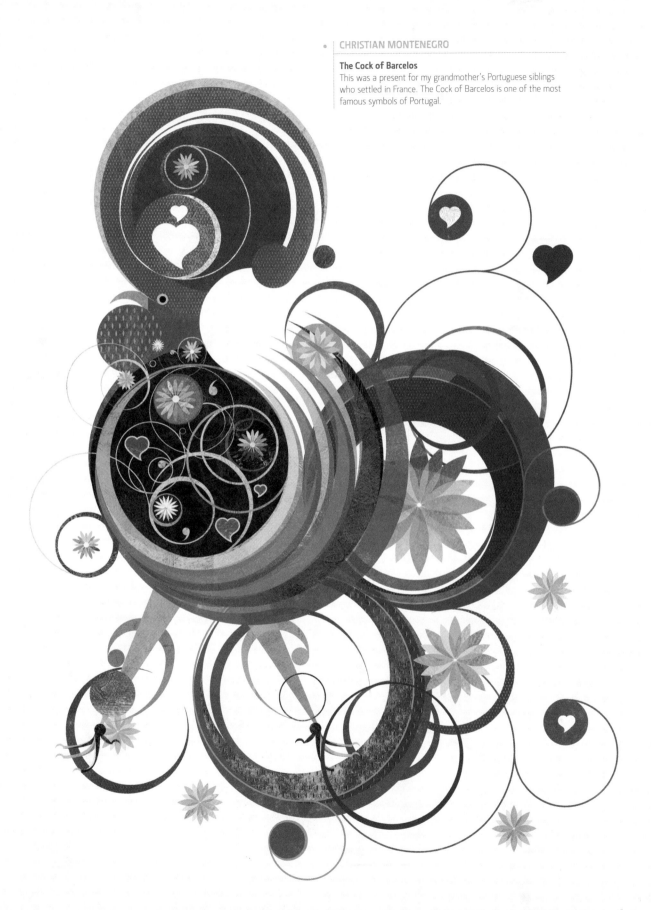

The Cock of Barcelos
This was a present for my grandmother's Portuguese siblings who settled in France. The Cock of Barcelos is one of the most famous symbols of Portugal.

• | TANIA DEPARES GARCIA

Felix Anastasio
Portrait of Felix Anastasio, a versatile
illustrator with a great imagination.
It was a present for all of our shared
moments of creativity.

• | TANIA DEPARES GARCIA

Julia Fritz
Portrait of Julia Fritz. Her gaze is
very suggestive, and I always find
something new in it. She is
a friend with so much feeling.

Birden

This is a piece I made for my parents to show them the state of anxiety I feel due to a series of family problems. I want to escape from this reality.

Dad

An birthday present for my father...gangsta style!

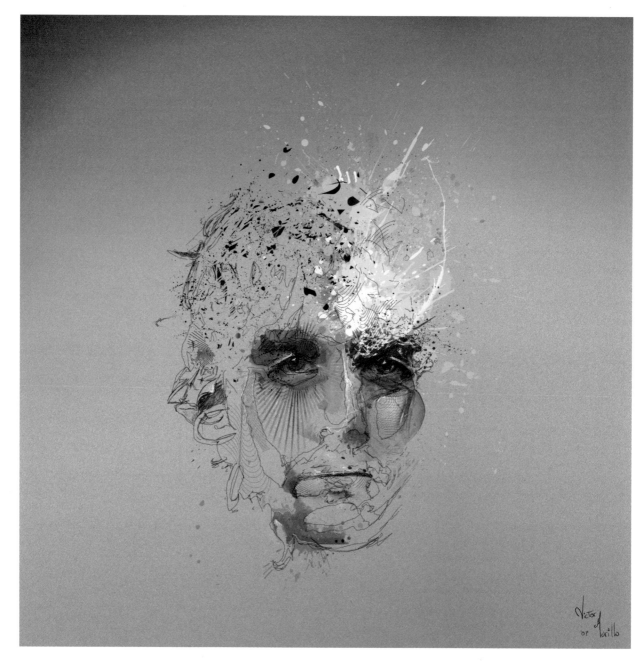

- | VICTOR MURILLO

Feel
This piece talks about the loneliness, sorrow and confusion reflected on this person's face, which is submerged in a complete lack of comprehension of everything around him, i.e., in nothingness.

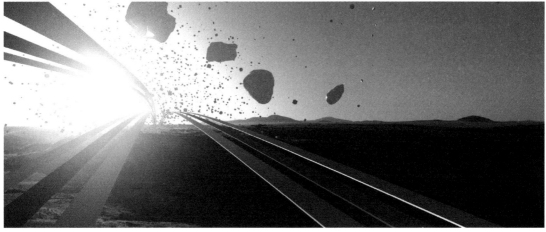

ENRIQUE RIVERA

Landscape
Simple and pure experimentation drove me to create this image. It was a gift for my mother.

ENRIQUE RIVERA

Namibia
The memory of Namibia, an amazingly beautiful country.

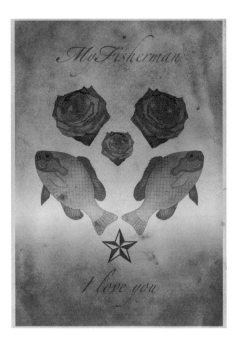

To My Fisherman
I really love making little
illustrated fliers to remind
friends that I love them.
Recently, I made this one for
my boyfriend, who loves to fish
and is loved by me.

•• | DIEGO CONTRERAS JARAMILLO

Earth
A screen-printed poster that I made
to give to family and friends on
Christmas.

• | JAUME OSMAN

Funny Face
An illustration/gift for a family
member.

TECKHARN KUANTH

One Happy Family
An illustration I made for the family and the friends I love.

VÍCTOR MANUEL MORAL MARTÍNEZ

Birds in the head
The idea came from my wife, who asked me how I would depict that expression in terms of graphics. It was something that described her, and according to her, I ended up turning what her relatives saw as a defect into something beautiful and poetic.

• | BRUNO SANTINHO

I made this piece to put next to my
girlfriend's nursing picture. It reflects
my own profession, illustration.

● | PABLO GOSTANIAN

2twenty
To Cosme, our inspiring muse. We owe you everything.

● | FRANCISCO MIRANDA

Trip
For friends who were going on a trip.

● | FRANCISCO MIRANDA

Things happen
It was my best friend's birthday.

• | MATTHIAS GEPHART

Private CD compilation artworks for close friends

I listen to music all day long—anything from different styles of goth, punkrock, hard core to some industrial, some minimal electro tunes, etc.—and I'm always discovering new bands. No less important, I love creating compilations, and I'm always working hard to combine the best tunes I've collected recently. Even if the sounds are from different styles or genres, I make it work somehow. I usually give these compilations a title related to something that affected me while I was preparing them. When it comes to their cover designs, I'm a real fanatic. Even though I used to work on them just as if they were real commercial projects, they are never seen by any public audience. I only give them to a very select group of very close friends as a present from time to time.

SANTI SALLÉS ARGILA

Various sketches of a potential toy
(a 12 cm plastic action figure).

SANTI SALLÉS ARGILA

I thought that if I designed a 3D
toy, it should come with a comic
showing its modus vivendi. The
truth is, it has a lot in common
with its creator.

● **SANTÍ SALLÉS ARGILA**

I decided to sketch the kitchen in my rental
apartment to remember it after I move out.

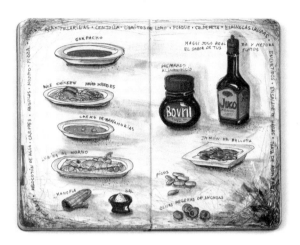

● **SANTÍ SALLÉS ARGILA**

What better way to express your food-related
whims than by drawing them?

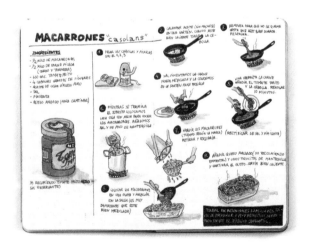

● **SANTÍ SALLÉS ARGILA**

I get lost making macaroni, so I decided to prepare
an illustration showing how I make them.

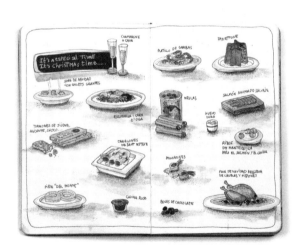

● **SANTÍ SALLÉS ARGILA**

An illustration of the dishes we usually prepare for Christmas.
I always have good memories of the holiday season.

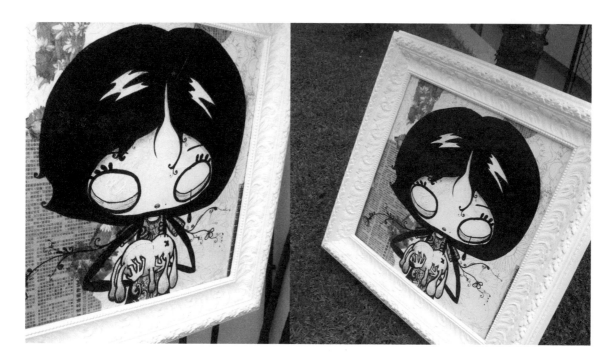

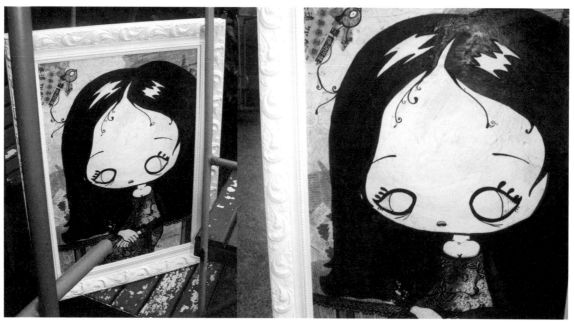

ELISA SASSI

Couldn't I squeeze it?
This is a painting for my mother. She is always squeezing me so hard that sometimes I think I'm going to die.

ELISA SASSI

Mona Lisa
I made this one especially for the friend who came up with the idea and gave the name to the painting.

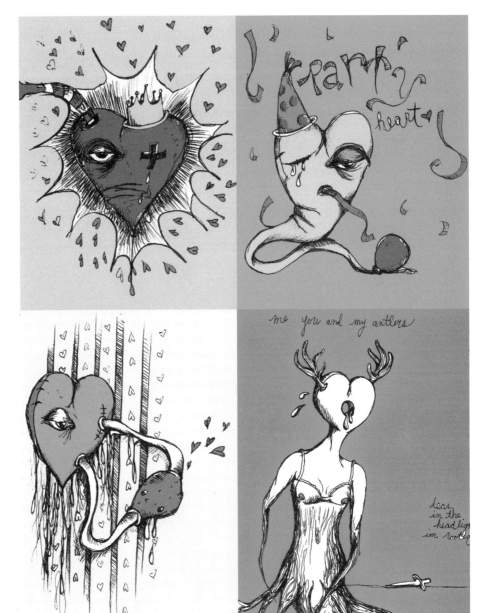

JILAWAN BUNNIMIT

"Sick Hearts Series" 2008
Life is a struggle to both maintain and cast off
our innocence. We like to believe that every
year, day, hour, we are learning from what
we are doing and are experiencing something
new. It seems that no matter what our life
experience, status or education, the one thing
we can never seem to constrain is love.

• | ANTONIO MORA

Insomnia
To highlight the features of an insomniac.
The eyes are open but tainted due to the
presence of disturbing dreams.

• | ANTONIO MORA

The fallen angel
The tragedy of an angel, who was
a chosen one in heaven and lost it
forever in a crackle of flames, horned
insects and burned wings.

JUST FOR YOU

ANTONIO MORA

Ecstasy
There you are, the wonderful instant
when the you merges with the world.

ANTONIO MORA

Prickly Antonio
A self-portrayal, the fateful demiurge of
a situation that dissipated like fog.

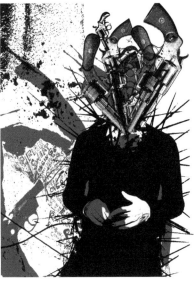

ANTONIO MORA

Heautontimoroumenos
To dive into the self-destruction and
explore the feelings of guilt of someone
who has murdered the person they love
without meaning to do it.

ANTONIO MORA

The scream
The broken clamor, a howl of dry,
crackling leaves, the loss of love.

CHAD KOURI

Collage for Letterform
Some good friends of mine bought a bunch of frames at a thrift store for their space. They were going to recycle the images that came in the frames but decided that it would be a better idea to give them to me to play with. As they handed them to me, I decided to make a piece with the images and give it back to them.

CHAD KOURI

Scotty's Birthday!
I never like buying things for friends for their birthdays—or any other holiday for that matter. I just do not think that spending X amount of money is a good way to show your gratitude for their friendship. I made this specific piece for my friend Scott Thomas's birthday.

MARIA EUGENIA PLATE

My Heart
I made this picture for someone
who made me feel really sensitive.

September at the seaside. This girl made me feel comfortable and eased my tension.

For once, I was sharing my life with someone. When I took this picture, the bed looked to me like the perfect shape of a love nest.

She was sitting on the bed. She slept in her clothes. She looked so nice and so delicate.

I started by taking pictures of my boyfriends in the bathtub, when I realized that there must be some connection between the end of my relationships and the fact that almost all of my lovers prefer taking baths over showers.

The girl with the bangs combed to the right is my flatmate. I've been living in flatshares for a long time, but as chance would have it, this time my flatmate also became a good friend. Here she is during a party in our flat. I love this smile.

I didn't even know him, but we found ourselves looking at each other for several seconds. When I lifted my camera up towards him, he suddenly understood my game and started posing for me. He became my subject and let me fall in love for 1/30th of a second.

DANIELA IONTA

He became a friend in no time at all

I've been temperamental for as long as I can remember, and it has always been hard for me to keep control of my feelings. Until I was 17 and discovered photography, that is. Since then, I have been taking pictures of my life. Over the last few months, my life has been going through some major changes, and these pictures tell the story of what has been happening to me and the new people I've met.

• The kitchen is my third favorite place after my bed and the darkroom. I wish my mother could see me. I'm used to cooking for my friends. Here I am with some friends, eating the pumpkin ravioli I made for them.

ALBA TENAS

Pregnancy
This is about the desire to immortalize
a unique instant, something that
only the person going through it can
feel, and help others imagine it. It is
also the desire to make a friend and
mother—and in the future, a son—
happy. And finally, it is the challenge
of trying to achieve all that.

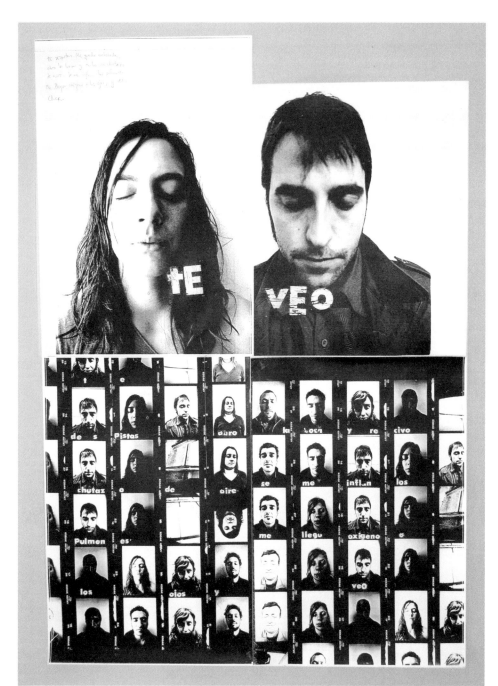

MARTA ABAD SÁNCHEZ

I See You All

I decided to take a picture of my friends in a very private moment, while they were sleeping. However, some of the pictures troubled me and made me think about everything we see without ever opening our eyes.

ATTILA BASSO

Adele
To commemorate the death
of my girlfriend, grandma.

• ATTILA BASSO

Bepi
To commemorate the death
of my grandfather.

Viola for Attila
This is a tribute to Attila's
love for Viola, his girlfriend,
a tribute my love for my
girlfriend.

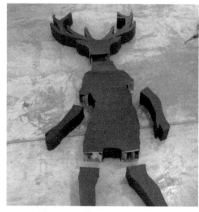 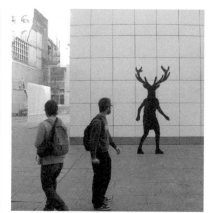 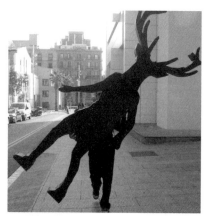
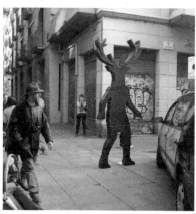
 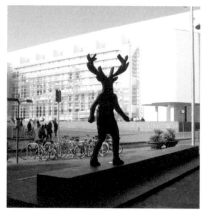

RUBÉN B

Deer woman

Women are my passion, and I love deer. It was just waiting to happen. The excuse was a group exhibition in Barcelona on AAAAA, a collection of picture books. I got to work (with the help of my friends at Picnic and The Gutenberg Collective, of course), and we decided to take her out for a walk to mix with people in the neighborhood. Afterwards, she went to Bilbao for a few weeks and then on to Madrid, where she is resting, dismembered.

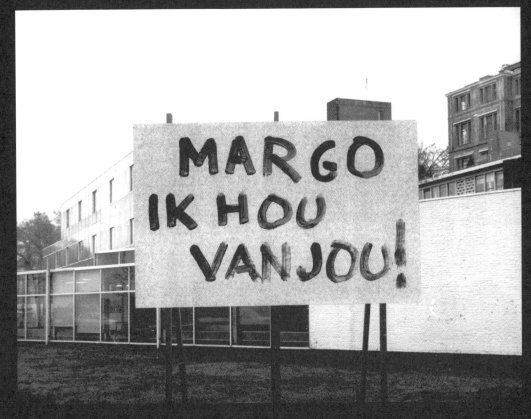

- **D. MARTIJN OOSTRA**

 A declaration of love
 I was in love.

- **ADRIÁN ARELLANO & MAURA ROSSI**

 The dog, his place and guide
 This photo was inspired by the dog that found the essential place, only to stay there even beyond the end of his existence. It is dedicated to him.

- **ADRIÁN ARELLANO & MAURA ROSSI**

 Drinking maté
 Maté, an Argentinean tradition par excellence, is the perfect excuse to get together with friends. What a moment!

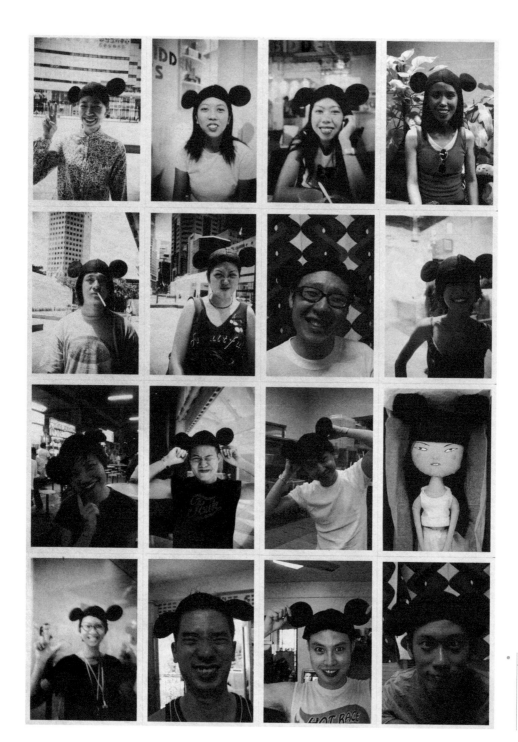

- | **TECKHARN KUANTH**

The Mickey Project
A series of photos taken of my lovely friends and family with the cartoon character I love.

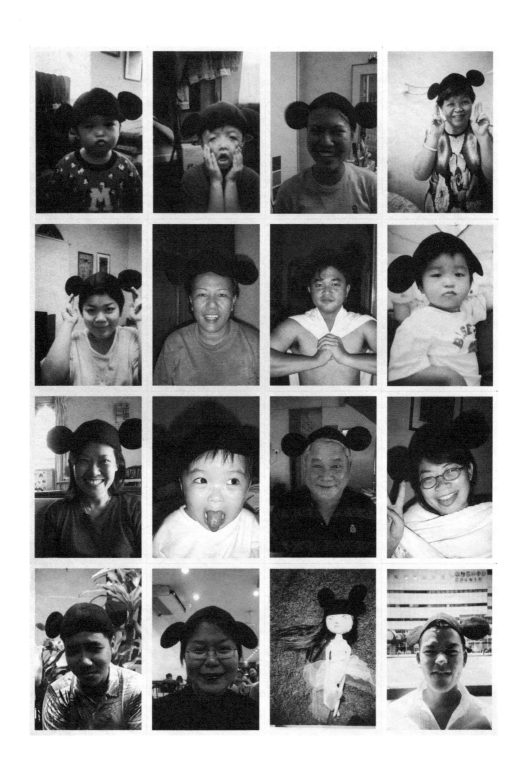

MARTA TORRENT

Everything got started the moment I remembered alout that when we were young, my girlfriends and I used to get together, dress up like fantasy characters and go take pictures of ourselves at the photo booth. Suddenly, my friends said it would be great if we could do it again and be little again for awhile. Only now, I am a photographer, and we were not going to take the pictures in the photo booth, but in my studio, of course!

● | MATTHIAS GEPHART

Pages from a unique calendar for my mom

It's a tradition in our family: every Christmas, my mom receives a self-made calendar from me. It is always a collection of photographs that fit with the 12 months. It's been like that for years, and when I go through my parents house, it is interesting to see how the style of my calendars has changed over the last 12 years or so. They are like a witness to my development as an artist. I see what I have been focusing on, and sometimes I laugh at myself. Other times, I am impressed by my old pieces and start thinking about how to get back to this or that way of seeing things.

MARIO RODRIGUEZ

Cap

We both like hip-hop, and I paint graffiti, so I painted a wall with a big rap hat, using her name as the brand. Then I took her there to see it as a surprise in the middle of the street. It went over really well.

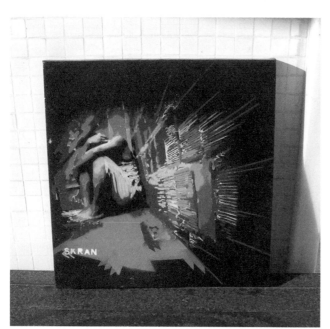

SKRAN MANIA

Alone in the DARK

This screen was an escape. I was going through some hard times; I was feeling lonely and felt like everything was going wrong. I needed an escape and a way to represent that hard moment that I was trying to overcome.

Graffiti 1

The first time I ever spray-painted graffiti. My first encounter with a wall. Lots of excitement. An unforgettable day. My friend Zeta was there with me. A wall is not an A4 sheet. (Elda-Alicante/2007)

MICHEL NOGUERA | MOG

Graffiti 2

My first graffiti with Namero! We had been wanting to paint together for a long time, and the day finally came in January 2008. Mixing our drawing styles was a very special experience. Another unforgettable day!

SKRAN MANIA

AlonBridge!

This was the first painting that I did for her. I has her face, flowers to symbolize the restaurant where we met, and a bridge that represents the distance between us. I live on the north side of the river, and she lives on the south side. This is the only bridge that separates us, and I have crossed it so many times to be with her.

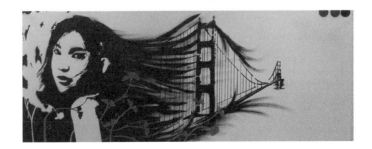

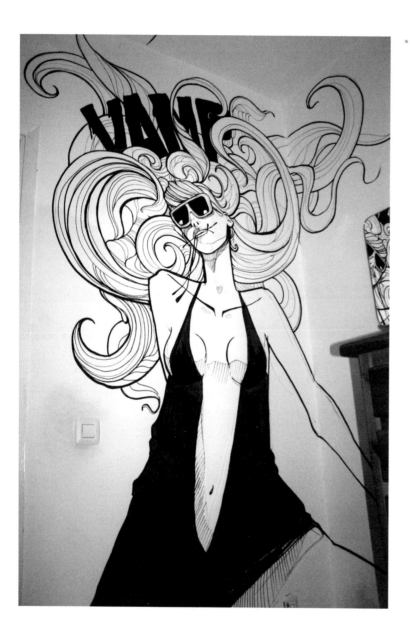

● | IKER MURO

David's House
A rainy day at my friend
David's house.

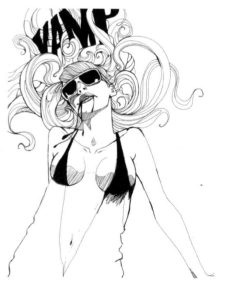

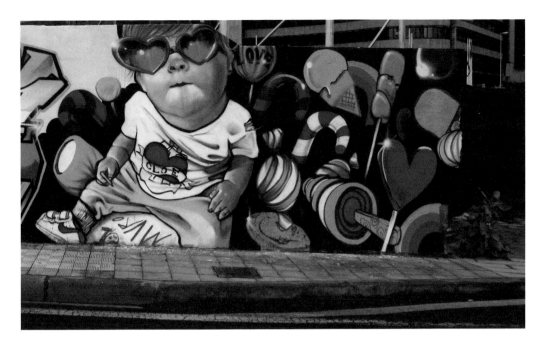

- IKER MURO

Cloe
My daughter's first birthday.

- MASOOD AHMED

Laura
I tagged this train in honor of my mother's 50th birthday. While she never approved of my art, it nonetheless touched her heart when I presented it to her.

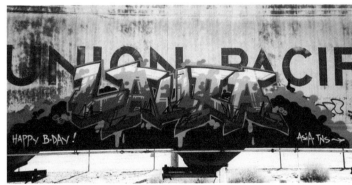

- MATTHIAS GEPHART

A silver piece for a girlfriend
The name of my girl at the time was Susan, and all of my friends call me Gee. As a manifestation of our related souls, I created a title for the phenomenon of our love and friendship: SUGEE. I did this silver piece at a nice spot and showed it to Susan one day when she came to visit my town. I did not tell her anything about it in advance. Even though it was only a silver style piece and not a big mural production, it was purely about us—and it was a success.

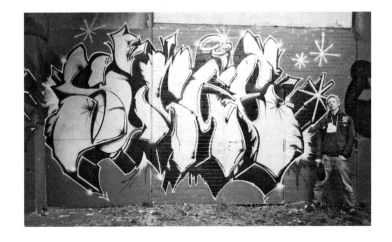

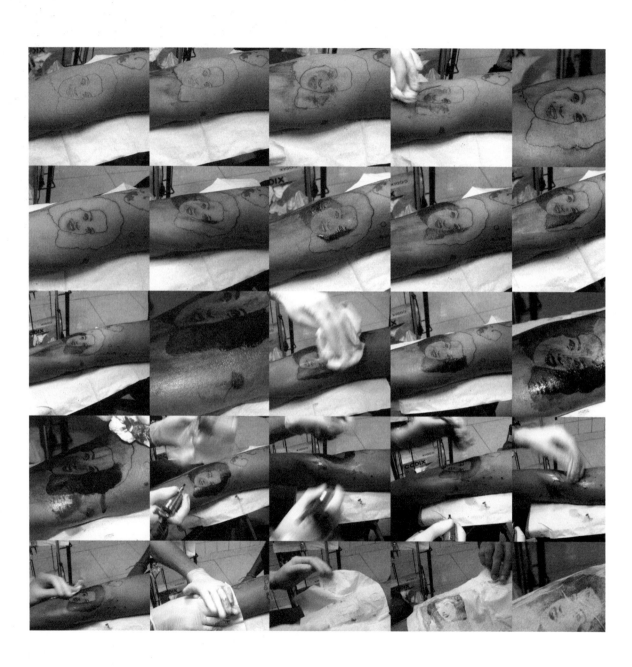

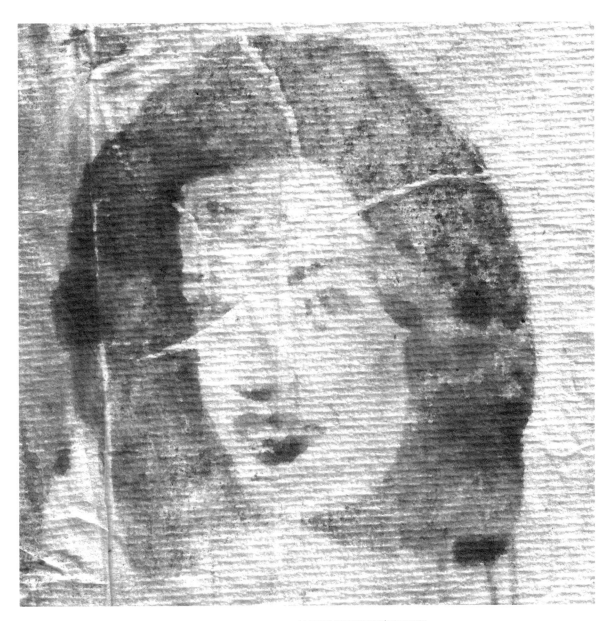

- MARTIN ALBORNOZ | BRUSTER

Blood stencil
A gift for my mother. An homage. A one-of-a-kind piece. Technique: blood on paper.

• MARTIN ALBORNOZ | BRUSTER

1x1 m wrestling stencil
This was a gift for Dr. Rueda, the gynecologist who looked after my daughter before she was born. He spent his time on ultrasounds, and I spent mine cutting out a 1x1 m stencil to make this piece. Technique: spray paint on canvas + acrylic.

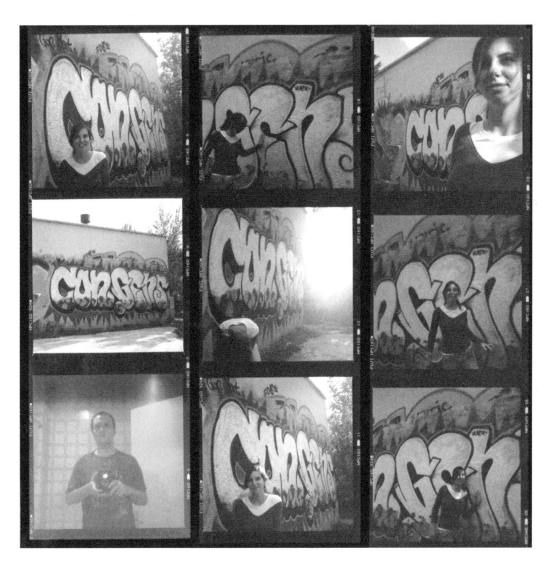

• CARLOS CORRAL MADRIGAL

A Story With Graffiti
This series of half-size camera shots shows the reaction of a very special girl for me the moment she saw by the light of day the first piece of graffiti she had ever done, made with my help the night before.

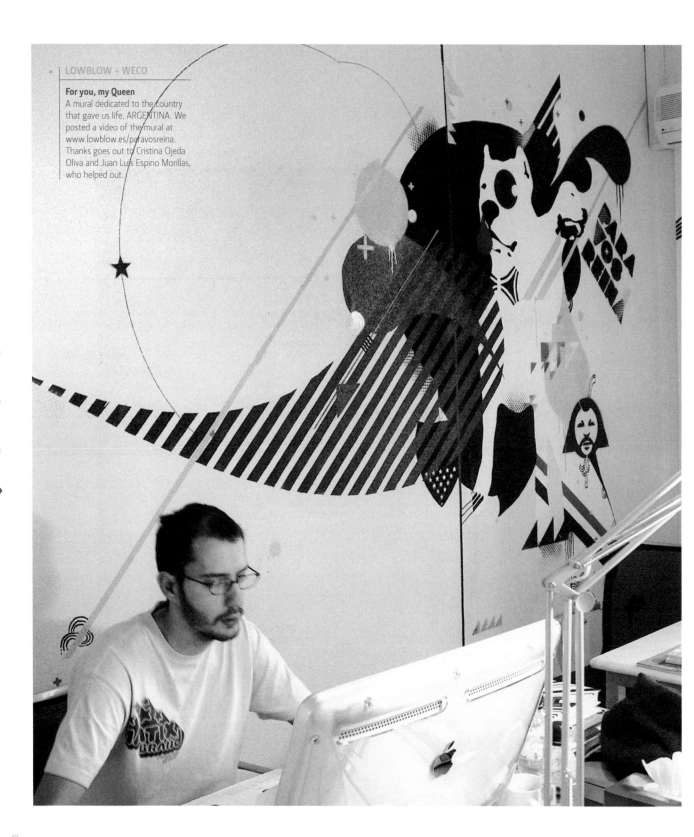

LOWBLOW + WECO

For you, my Queen
A mural dedicated to the country
that gave us life, ARGENTINA. We
posted a video of the mural at
www.lowblow.es/paravosreina.
Thanks goes out to Cristina Ojeda
Oliva and Juan Luis Espino Morillas,
who helped out.

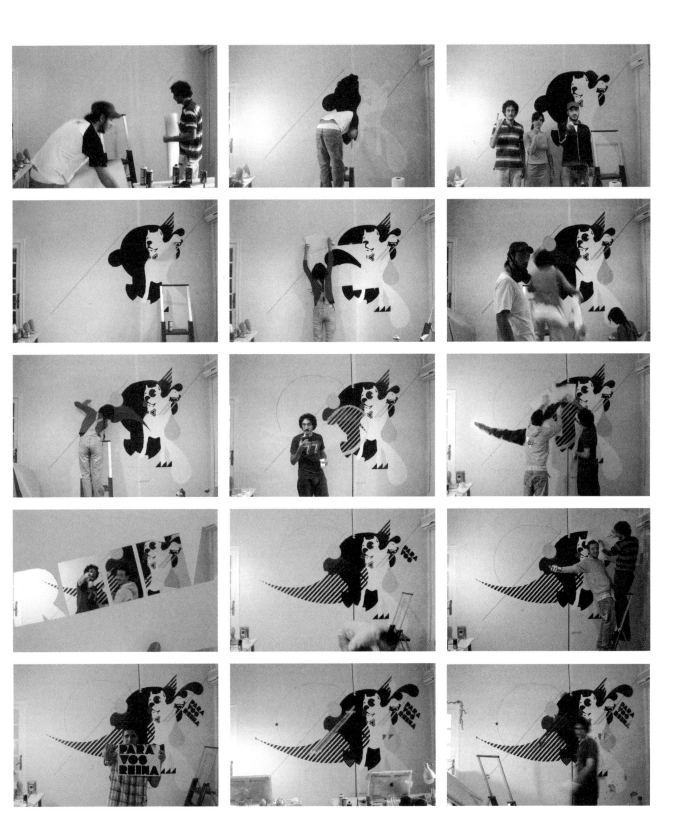

ASHD

Graffiti loves you!

The graffiti subculture is a system of action that renegotiates the social significance of public space. The city is a nest for graffiti writers to express their art. Writers capitalize on the fact that shared public space leads to a mass spectacle and take advantage of the possibilities for public exposure in the city. Although graffiti is permanently in the public eye, its codes and language are alien to most people. As we can see now, graffiti art dramatically changes the visual landscape and awakens the eyes of passers-by just as communication and advertisements do. Show some love to this urban art and stop hating it. This piece of mine is specially dedicated to the masses who have a negative impression of this art form.

ALBERT SANTANACH

Rest in peace, COBI

For the death of a loved one. Dedicating a wall was the best way to remember him.

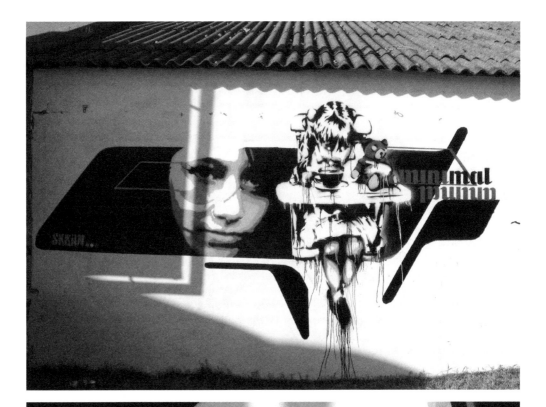

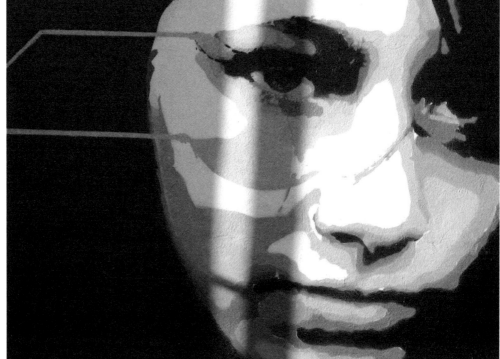

SKRAN MANIA

Mammy

This is a painting that we had dedicated to our mother. We are two brothers (Skran and Minimalanimal), and we represented two different people. On the left side is our mother, and on the right side is our sister who died before she was born. This was near our's mother house and was a demonstration of love and respect, not only for the excellent mother that she has been but also to our sister whom we have never met.

Index of pieces

índice de colaboradores

A
ABAD SÁNCHEZ, MARTA [269]
www.agitaciografica.com

ABREGO BLANCO, EDUARDO [56-57]
www.kalipo.com/axb

ACHOYAN, DANIELA [43]
www.estudioplaneador.com.ar

AGOSIN, ANDRES [113]
www.revistagooo.com.ar
www.monkdesign.com.ar

ALBORNOZ, MARTIN | BRUSTER
[166-167-274-275-276]
www.brusterspecial.com

ALONZO CORREA, CARLOS [156]
www.weeatdesign.com

APARICIÓ MARCOS, NÚRIA [194-195]
www.lapendeja.net

ARABENA, YANINA [24-59]
www.flickr.com/yaniarabena

ARELLANO ADRIÁN & MAURA ROSSI [263]
www.flickr.com/photos/photo_break

ARRAIANO, PAULO [179-171]
www.pauloarraiano.com

ASHD [280]
www.ashd-roc.com

ATIENZA ALCAIDE, JERÓNIMO [173-181]

B
BAKER, CHRYSTAL [54]
www.yesdesigngroup.com

BASSO, ATTILA [177-260-261]
www.flickr.com/photos/viola_attila

BENFOR [191]
www.benfor.biz

BENINTENDE, SALVATORE | TVBOY® STUDIO
[62-79-83-192-193]
www.thetvboy.com

BEZANILLA ORALLO, GERARDO [122-224]
www.beusual.com

BLASCO, JULIO [111-206-207]

BLASCO, SUSANA [119]
susanablasco.com

BLOHMÉ SARA [176]
www.lula.se

BÖRRIS PETERS, BJÖRN [50-132]
www.designklinik.de

BORRUT, JONA [126-127]
missstellap.blogspot.com

BUCH BARRIS, DANI [123]
www.danibuch.com

BUNNIMIT, JILAWAN [110-203-251]
www.misscake.com

BURLESON, KARIANN [26-27-28-29]
www.dailypoetics.com

BUSTELO, ANA [61-214-215]
www.anabustelo.es

C
CAFFARONE, MARA [72]
www.flickr.com/unknown_

CALVET, LAIA [56-66]
www.fanzinemalalletra.blogspot.com

CARACCIOLO, NICOLAS [134-135]
www.kurcho.com

CARNICER GUZMÁN, ANA [44]
www.carnicermaraia.es

CARRERAS, ALBERT [66-73]
www.brandattack.net

CASTELLO, MIKE [185]
www.mikecastello.com

CASTRO, JEROME | HELLOFREAKS [163]
www.hellofreaks.com/

COBO CANO, PEDRO [186]

CONTRERAS JARAMILLO, DIEGO [48-242]

CORRAL MADRIGAL, CARLOS [271]
www.corralmadrigal.com

COURTNEY RIOT [174]
www.courtneyriot.com

D
DANSA ARNAIZ, MARTA [71-75]
www.iluilus.com

DE ALMEIDA, JULIE [86-87]
tipiak.blogspot.com

DEL ROSAL ORTIZ, NAZA [208]
www.myspace.com/soy_de_mentira

DELANEY, SARA [222]
www.delaneygroup.com

DENBLEYKER, CASEY [51-116]
bungalowcreative.com

DE NICOLÁS GÓMEZ, MYRIAM [111]

DENZER, MAJA [114-115-141]
www.gestaltica.de

DEPARES GARCIA, TANIA [238]
www.taniadepares.com

DE RAMON GUTIERREZ, DAVID [229]
www.davidderamon.com

DERMENGHEM, ANNE-LISE [47]

DIAZ FERNANDEZ, RICHARD [144-145]
www.fotolog.com/bizancio

DIDIEGO, MARIA EUGENIA [226-227]

DOBROV VASILIEFF, MARINA [123-136]
marinavasilieff.blogspot.com

DR MANTA [20-21]
www.mantagraphics.com

DULUDE, DENIS [104-105]
www.dulude.ca

E ECKERT, VICTORIA [100]
www.estudio-ez.com

ECKSTEIN, VANESSA [80]
blokdesign.com

EMBÚN COROMINAS, GOTI [236]
www.eggeassociats.net

ERNEX [239]
www.ernex.es

ESCALERA MOURA, ANA | HOLA POR QUÉ [30-35]
www.holaporque.com

ESTEBAN, MANUEL [232]
www.manuelesteban.com

ESTÉVEZ, ROSITA [173]
www.behance.net/Rosita1983

F FIILIN, JUHA [36-37-233]
www.fiilin.com

G GARCÍA CRUZ, MARIANO DAMIAN [213]
www.mariano-garcia.com

GEPHART, MATTHIAS [247-268-269-273]
www.disturbanity.com

GIORDANO, PHILIP [183]
www.pilipolare.blogspot.com

GOETZ, SILJA [147]
www.siljagoetz.com

GÓMEZ BERNAUS, ANA [172]
www.anenocena.com

GOMEZ DE LAS HERAS, BELEN [56 - 58]

GÓMEZ PEÑAS, BLANCA [107]
www.cosasminimas.com

GONZÁLEZ VILLAMAÑÁN, EDUARDO | HOLA POR QUÉ [30-34]
www.holaporque.com

GOSTANIAN, PABLO [246]
www.2veinte.com.ar

GNOATTO, MARIA CARLA [31]
www.carlagnoatto.com.ar

GRAZIOLINO, PAOLO [38-39]
www.supergordo.com

GREGORI, SANTI [50]
www.santigregori.com

GRIMALDI, ILARIA [139]

GROSSI, ESTER [186]

GUIDICI, JULIETA [186]
www.julietaguidici.com.ar

GUTIERREZ, MARTIN LUCAS [120]

H HELTON, MARK [80-112]
www.iammarkhelton.com

HENSCHEL, MAX [138-148]
www.mhg.ch

HERNANDEZ, MAR | MALOTA [12]
www.malotaprojects.com

HJGHER, JUSTIN [25]
www.hjgher.com

I IGLESIAS PASCAU, MARIA [42]

IONTA, DANIELA [256-257]
www.danielaionta.carbonmade.com

J JIEM [14]
laluchasigue.free.fr

JUANHUIX FUENTES, XAVIER [13]
www.myspace.com/ninoosbysoledades

K KADHIJA, NATACHA [203]

KASS, ERIC [49-156]
www.funnel.tv

KATRINA, RYAN | NEUARMY [70]
www.neuarmy.com

KICILLOF, JONATHAN LUIS [142-152]

KIRCA, PELIN [68-69]
pelinkirca.com

KLEEBERG, PATRICIA [76-154]
www.neon-o.com

KLETT, ISABEL [33-188]
www.isabelklett.de

KOHN, ILANA [228-229]
www.ilanakohn.com

KOURI, CHAD [143-254]
kouridesign.com

KUANTH, TECKHARN [82-83-141-189-243-264-265]
www.kuanth.com

L LARA, CARLOS [197]
www.carloslara.net

LAURORA, NICO [163]
www.nico189.com

LAW, CHINTHYE [223]
www.designdesigners.com

LEE, JOANNE [152-157]
www.bitterjo.blogspot.com

LEON RODRIGUEZ, ALVARO [96]
www.keloide.net

LEVITT, MARC S. [106]
www.mslk.com

LIBELLULART S.N.C. [108]
libellulart.com

LINFATTI, MARTA [242]

LIVSCHITZ, LUCILA [173]
bunny.velvethurricane.com.ar

LLORENS, OSCAR [184]
ollorens.com

LOPEZ NUÑEZ, FRANCISCO [230]
www.dredystudio.com

LÓPEZ, GUSTAVO [159]
www.glm-studio.com

LÓPEZ MONSÓ, ROSER [13]
www.myspace.com/ninoosbysoledades

LOWBLOW + WECO [278-279]
lowblow.es

M MACHADO, DIOGO | ADD FUEL TO THE FIRE
[81-155-196]
www.addfueltothefire.com

MACÍAS RAMOS, ROCÍO [67-79]
www.elperrovuela.com

MANCERA, ELIANE [31]
www.elylu.com

MANZOTTI, DANIELA [55]
www.danielamanzotti.com

MARTEL, DANIEL [180-211]
www.danielmartel.com

MARTÍ SAÉZ, MATI [158]
www.lemonart.com

MARTIJN OOSTRA, D. [133-263]
www.martijnoostra.com

MARTÍNEZ BALLESTEROS, NACHO [218-219]

MARTINEZ LAHIGUERA, JUAN [46]
www.martinezestudio.com

MARZARO, CARIN [78]
www.enjoykerin.com

MASCHA, DAVID [150-151]
www.davidmascha.com

MASOOD, AHMED [273]

MAXIME, LEVESQUE [90-91-92-93-94-97]
www.maximelevesque.ca

MAZON BALLESTER, MIGUEL ANGEL [109]

MENDOZA CUEVAS, NOÉ [22-23-38-39]
www.srpiruleta.es

MIRANDA, FRANCISCO [209-246]
www.flickr.com/photos/tooco

MODÉN, KARI [118]
www.karimoden.se

MONTENEGRO, CHRISTIAN [237]
www.christianmontenegro.com.ar

MORA, ANTONIO [252-253]
www.antoniomora.net

MORA, TXEMA [153]
www.celophan.com

MORAL MARTÍNEZ, VÍCTOR MANUEL
[178-179-243]
www.biticol.com

MORALES, MARTA [76]

MORILLAS, MAMEN [77-210-212]
www.agentemorillas.com

MUNK, KENN [51-101-181]
www.kennmunk.com

MURILLO, VICTOR [240]
www.murillo-design.com

MURO, IKER [272-273]
murocracia.com

MUSAWORKLAB [101]
www.musaworklab.com

N NARVÁEZ, JAIME [217]
www.jaimenarvaez.com

NIES, LUCÍA [177]
www.lucianies.com.ar

NOGUERA, MICHEL | MOG
[71-78-175-196-212-271]
www.myspace.com/mografik
nammog.com

NOGUERAS, LAURA [102]
www.saladoscomunicacio.com

O OBLAK, MATEJA [103]

OLIVEIRA, JOANA [80]

OLIVER, PATRICIO [181]
www.patriciooliver.com.ar

ORPANA, ELINA [220-221]
www.elinao.com

OSELLA, SILVIA [66-176]
www.silviastella.com

OSMAN, JAUME [143-152-161-203-204-213-242]
www.mentesperturbadas.com

P PALMA FUSTER, JOSE | DIGITAL POINT
[137-164-204-239]
www.digitalpoint.es

PEDRERO DÍAZ, SARA [19-52-53]
blog.iespana.es/piedragirl

PÉREZ MARCO, FRANCISCO [142-218]

PIMENTEL, PETER [114-121]
smashlab.com

PLATE, MARÍA EUGENIA [255]
pinyta-pinyta.blogspot.com

R RAIDY, MARIEJOE [231]
www.mariejoeraidy.com

REDONDO, IVÁN [211]
www.dxl.es

RESTREPO, SANDRA [95]

RIAGUAS OLIVA, MARTA [42]
www.martariaguas.com

RIBEIRO, CARLOS [98]

RIVERA, ENRIQUE [241]
www.d-noise.net

RODICA, JERNEJA [74-74]

RODRÍGUEZ COLLAR, EVA | YELLBROAD [106-132]
www.yellbroad.com

RODRIGUEZ, MARIO | CALMA
[18-40-138-146-154-187-224-231-270]

ROTGER MIRÓ, DAMIÀ [160]
www.ductilct.com

RUBÉN B [262]
www.picnic.la

S SAAVEDRA, NOEMÍ [209]
illustrationwen.blogia.com

SAGRAMOLA, GIULIA [72-73]
www.giuliasagramola.it

SALLÉS ARGILA, SANTI [15-248-249]
www.santisalles.com

SANTAMARINA, JOSÉ
[44-45-100-102-107-140-143-216]
www.santamarinadg.com

SANTANACH, ALBERT [280]
www.bifid.net

SANTINHO, BRUNO [244-245]

SANZ ESPARZA, DIEGO [65]
www.vudumedia.com

SANZ IMBERN, RICARDO [234-235]
www.himbern.com

SASSI, ELISA [14-250]
elisasassi.com

SAYLES, JOHN [41-99-132]
www.saylesdesign.com

SCHMAL, CRISTO [16-17]
www.artnomono.com

SCHOSTOK, THOMAS [158]
www.ths.nu

SEAMAN, RYAN [157]
www.designbyrds.com

SERRA, ADOLFO [62-77-182]
karkoma.com

SHIMIZU, YUKO [124-125]
www.yukoart.com

SKRAN MANIA [270-271-281]
myspace.com/skran

SOKKUAN TYE [84-85]
sokkuan.blogspot.com

SOLA, JUSTIN [190]
designedbyskin.com

T TAN, AGNES [64-117]
www.yuccastudio.com

TENAS, ALBA [258]
www.shiiva.net

TESORIERE, FRANCESCA [229]
ftesoriere.blogspot.com

TOLEDO BLANCO, LUIS [152]
prisa-mata.blogspot.com

TORRENT, MARTA [32-266-267]
www.myspace.com/lookatmecolumna

TRISTÁN, ISABEL [63]

TWYMAN, LUKE [64]
www.whitevinyldesign.com

V VALERO RECAS, LAURA [44]
www.lauravalero.com

VAN HET NEDEREND, HENK | MOKER ONTWERP
[138-149]
www.mokerontwerp.nl

VAROL ERGEN, ELIF [198-199-200-201]
eno-shima.deviantart.com

VASSAL'LO FERNÁNDEZ, LUIS [60]

VÁZQUEZ SUTILO, SOLEDAD [205]
www.ojoplatico.com

VERTIGO GRAPHIX [202]
www.vertigographix.com

VIGIL-ESCALERA, LORENA [128-142]
www.flickr.com/photos/lov_e

VILLA LARGACHA, FRANCISCO [162]
www.flickr.com/photos/shimpallavi

W WALDEN, CHRISTIAN [108-219]
www.dmyk.com

WATERS, SEBASTIAN [230]
www.sebastianwaters.com
www.zehnuhr.de

WECO [129-132-142-164-225]
www.weco.com

Y YAMADA, EMILIA [108]
www.flickr.com/photos/14304425@Noo

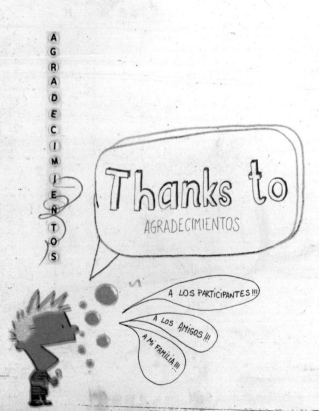

AGRADECIMIENTOS

Thanks to

AGRADECIMIENTOS

A LOS PARTICIPANTES !!!

A LOS AMIGOS !!!

A MI FAMILIA !!!

It has been more than a year since I first came up with this project. I was taking a shower when I started to think about the things that I had done in my life for the people I love, sometimes with almost no time or recources, but always with the same goal in mind: to deposit a special memory of a shared moment in something so personal, so mine.

I must confess that I could hardly sleep while I was preparing this book. I am sure I was like a zombie the next day at work, but I loved coming home in the evening and downloading e-mail after e-mail after e-mail, answering them, translating, having dinner, and then looking at more and more e-mails. I spent my nights this way, anxious and excited to download the next message and find out yet another way to say "I love you".

I felt happy to know that I was not the only one thinking about this, and time did not matter;

something special was happening in my life. I think it would be wonderful if you too could look beyond the designs and illustrations in this book and discover the stories of people who felt the need to express what they feel through their work.

Today, the 18th of July, 2008, as I am finishing the design of this last page, which I have intentionally left for the end, I want to dedicate this book to all those people who have taken part in the project and sent in their personal stories. You have made this project something more than just a simple book. Thank you.

Special thanks for their collaboration go out to Mario Rodríguez, Carmen Pacheco, Myriam De Nicolas, Pablo F., Jaime Gasset Rosa and Diego García.

Thanks to my family and friends, who, though far away, make me feel so close: Ariel Correa, Alain Borrego, Mabel Ollari, Nicolás Correa, Daniel Correa, Liliana Wentlant, Luis Rofrano, la Yeya, Adrián Arellano, Maura Rossi, Mariano Cerrella "Coco", Eduardo Bergara Leuman, Fernando Lendoiro, Daniela Achoyan, Carolina Rosso, Lisandro Cocorda "Lisobono", Luis Kicilloff, Lucas Tonet, Maria Eugenia Plate, the people at uni, Ariadna Fernández, Sergio Matteucci, Gabriel Struminger, Marcelo De Francesco, David Arcavin, Patricio Sohn, Noé Mendoza, Victor Santacruz, Kluster & Fluster, Janina Levin, David Cucoror, Daniela Ionta, Héctor De Paz, Gastón Caminata, Olmedo y Porcel, Ulises Martin, Ludovica Squirru, Natalia Bellagio, Andrea Lamas, Paola Laine, Cristina Pérez Ballester, Rosete Brothers' and Lucas Bols.

And a special kiss to Marta Rifà Orell for her patience and support in this infinite madness.

Pablo Correa.

BUENOS AIRES ENAMORADO

Cuando TE ENAMORAS QUIERES VOMITARLO, sal a la calle y gritarlo, QUE el MUNDO SE ENTERE.

Walking around Buenos Aires a few months ago, I paid special attention to what the walls were saying to me. Graffiti, paintings, stencils. The need to express feelings and proclaim that love is still alive. Shouts spat out when turning the corner. Buenos Aires is a cloud of eye poems that look at you from every corner. I can't help but think of the "Laura, I love you" message on school walls. In the streets, my entire city is shouting that we want to be less alone. Six years later, I look back and feel that nothing has changed in all those corners. Buenos Aires is still in love.

TÍPICO CARTEL PASA-
CALLES, TE ENCUENTRAS
TELAS IMPRESAS CON
FRASES DEDICADAS A
LA FAMILIA, AMIGOS O
PAREJA

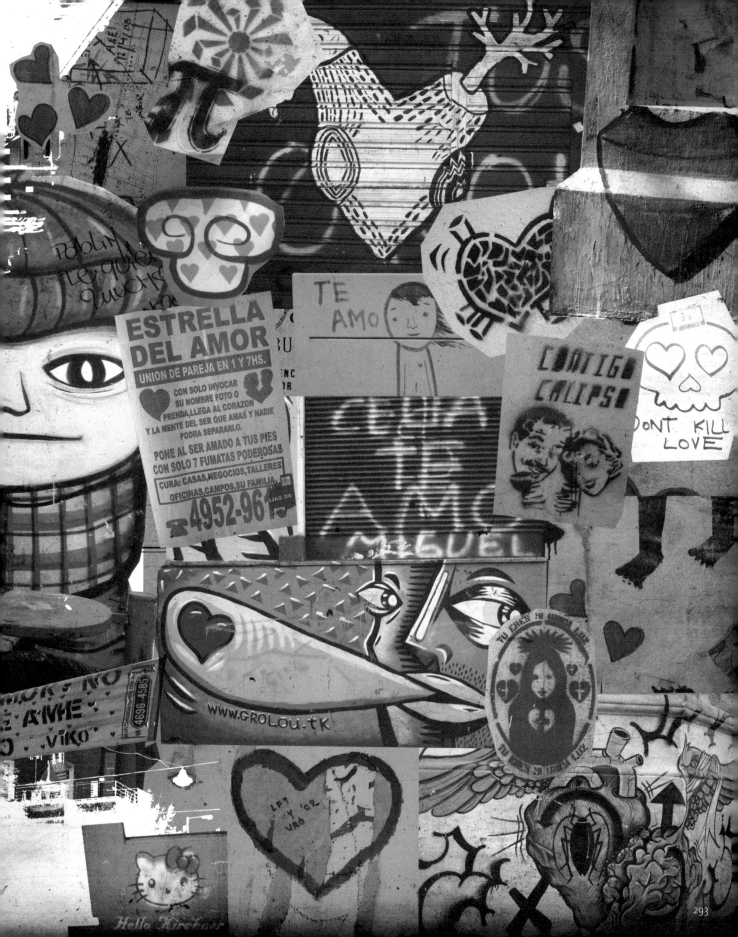

293

ariel

Thanks
to my
Family
FAMILIA

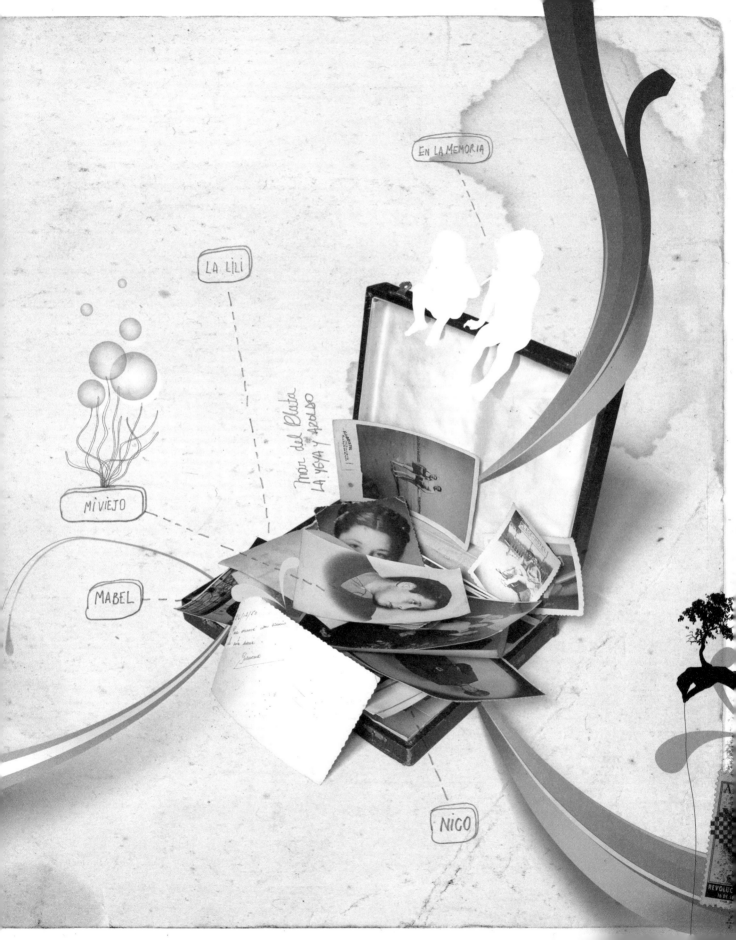

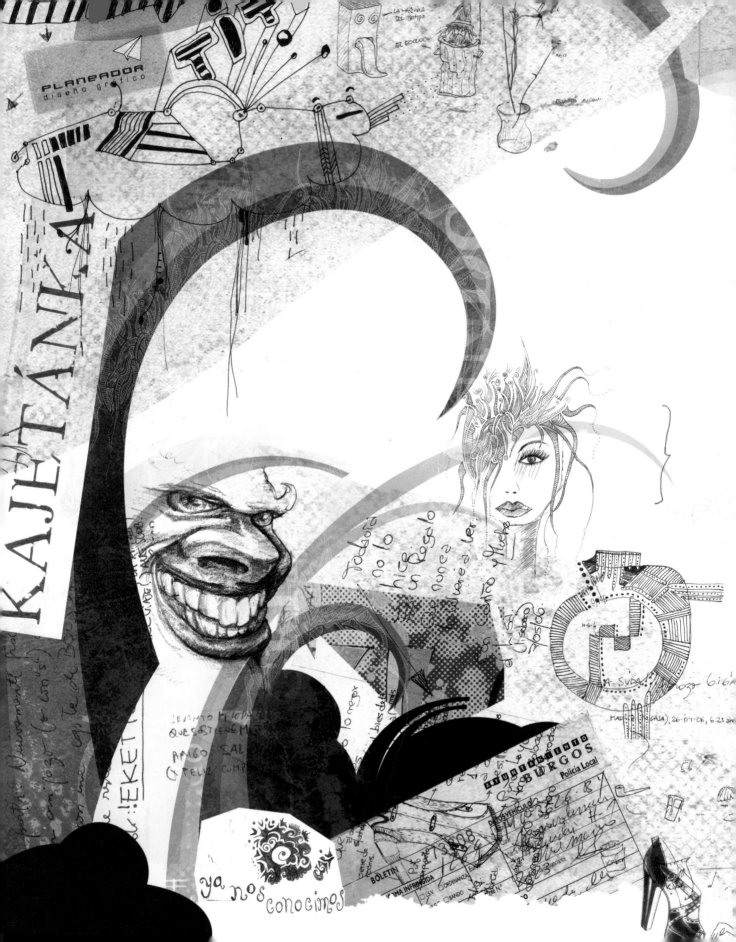

Miri's pelambres...

MY Friends
AMIGOS

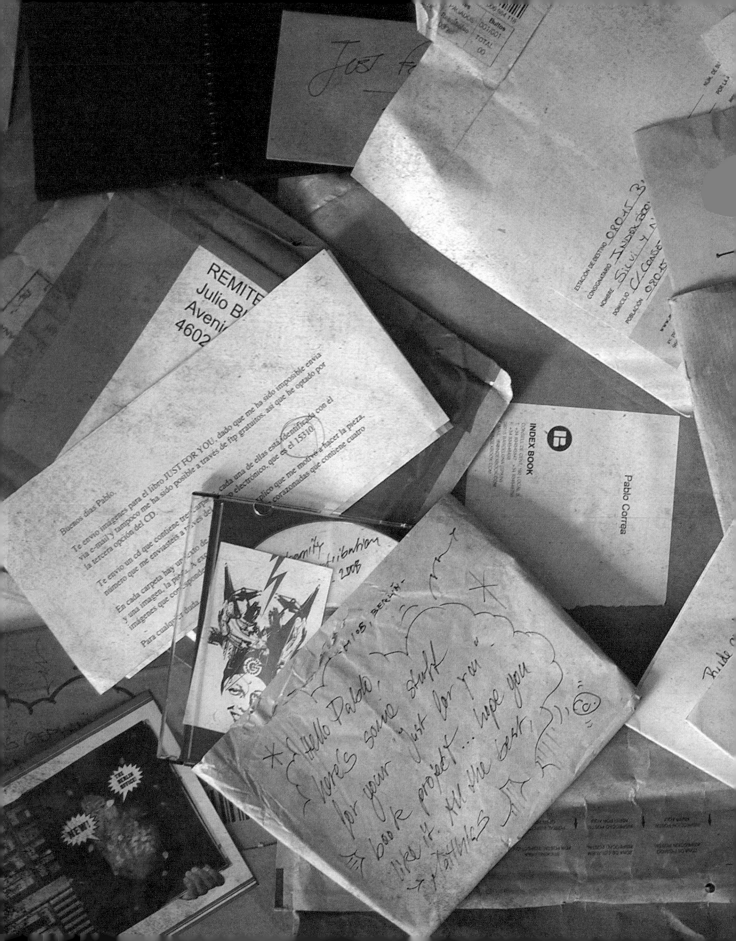

Just for you

DESIGNS FROM THE HEART

The typefaces used in the composition of **"Just for you"** are Section Light, Section Bold, and Traveling Typewriter. Hand-lettering is used on the divider pages.